Walter Foster

COLLECTIBLES

How to Draw •

classic

Heads & Faces

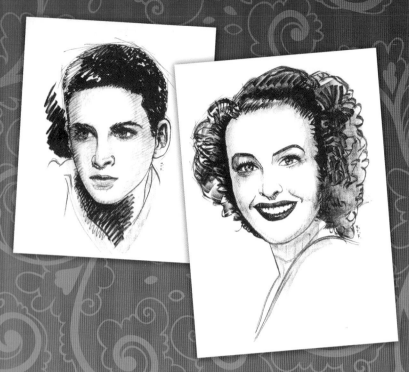

Table of Contents

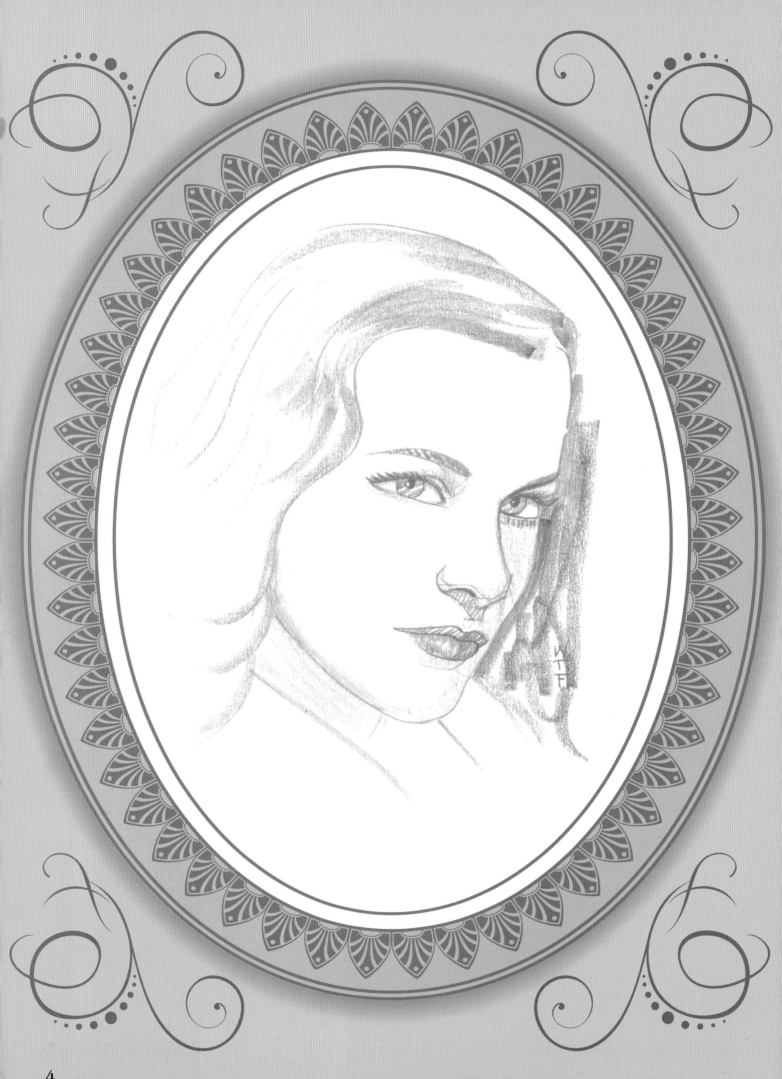

Chapter 1: Introduction

Step back in time and get newly acquainted—or reacquainted—with the original art of Walter T. Foster, as you take an incredible artistic journey through four vintage works: *How to Draw the Head, Drawing Faces, Heads from Life,* and *101 Heads.* For artists, few things are more fascinating—or challenging—than drawing the human face. No two faces are exactly alike, and being able to capture human emotion in a drawing is among an artist's greatest achievements. This comprehensive book features easy-to-follow drawing instructions for a wide range of classic heads and faces—male and female, young and old—in a variety of positions, including profile, three-quarter, and frontal views. You'll learn the elements of proportion and perspective, how to draw individual facial features, simple shading techniques, and more. And with practice and perseverance, you will soon be on your way to developing your own unique drawing style!

Tools & Materials

One of the best things about drawing is that you can do it anywhere, and the materials are relatively inexpensive. Here are some supplies you will need to start drawing the classic heads and faces featured throughout this book.

▶ *Sketch Pads* Sketch pads come in many shapes and sizes. Although most are not designed for finished artwork, they are useful for working out your ideas.

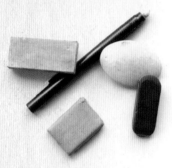

◀ *Drawing Paper* Drawing paper is available in a range of surface textures (called "tooth"), including smooth grain (plate finish and hot pressed), medium grain (cold pressed), and rough to very rough. Cold-pressed paper is the most versatile and is great for a variety of drawing techniques. For finished works of art, using single sheets of drawing paper is best.

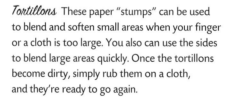

Erasers There are several types of art erasers. Plastic erasers are useful for removing hard pencil marks and large areas. Kneaded erasers (a must) can be molded into different shapes and used to dab at an area, gently lifting tone from the paper.

Tortillons These paper "stumps" can be used to blend and soften small areas when your finger or a cloth is too large. You also can use the sides to blend large areas quickly. Once the tortillons become dirty, simply rub them on a cloth, and they're ready to go again.

Utility Knives Utility, or craft, knives are great for cleanly cutting drawing papers and mat board. You also can use them for sharpening pencils (see page 7). Blades come in a variety of shapes and sizes and are easily interchanged.

Charcoal Paper Charcoal paper is available in a variety of textures. Some of the surface finishes are pronounced, and you can use them to enhance the texture in your drawings. These papers come in many colors, which can add depth and visual interest to your work.

Work Station It is a good idea to set up a spacious work area with ample lighting. Of course, having an entire room with track lighting, an easel, and a drawing table is ideal; however, all you really need is a place by a window for natural light. When drawing at night, use a soft-white light bulb and a cool-white fluorescent light so that you have both warm (yellowish) and cool (bluish) light.

Drawing Pencils

Drawing pencils contain a graphite center. They are sorted by hardness, or grade, from very soft (9B) to very hard (9H). A good starter set includes a 6B, 4B, 2B, HB, B, 2H, 4H, and 6H. Pencil grade is not standardized, so it's best for your first set of pencils to be the same brand for consistency. The chart at right shows a variety of pencils and the kinds of strokes that are achieved with each one. Practice creating different effects with each one by varying the pressure when you draw. Find tools that you like to work with. The more comfortable you are with your tools, the better your drawings will be!

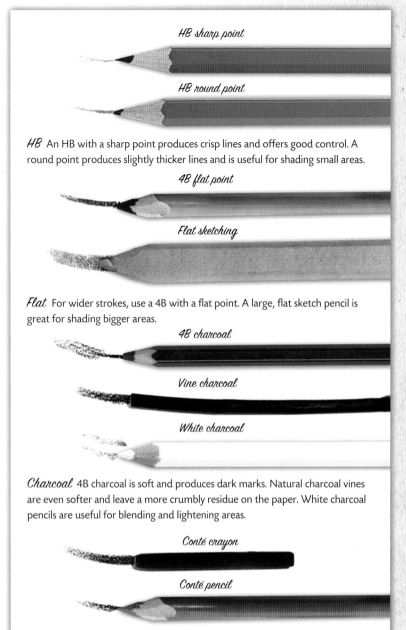

HB sharp point

HB round point

HB An HB with a sharp point produces crisp lines and offers good control. A round point produces slightly thicker lines and is useful for shading small areas.

4B flat point

Flat sketching

Flat For wider strokes, use a 4B with a flat point. A large, flat sketch pencil is great for shading bigger areas.

4B charcoal

Vine charcoal

White charcoal

Charcoal 4B charcoal is soft and produces dark marks. Natural charcoal vines are even softer and leave a more crumbly residue on the paper. White charcoal pencils are useful for blending and lightening areas.

Conté crayon

Conté pencil

Conté Crayon or Pencil Conté crayon is made from very fine Kaolin clay and is available in a wide range of colors. Because it's water soluble, it can be blended with a wet brush or cloth.

Pencil Key

- Very hard: 5H–9H
- Hard: 3H–4H
- Medium hard: H–2H
- Medium: HB–F
- Medium soft: B–2B
- Soft: 3B–4B
- Very soft: 5B–9B

Other Drawing Essentials Other tools you may need for drawing include a ruler or T-square for marking the perimeter of your drawing area, an inexpensive drawing board, and artist's tape for attaching paper to your board or a table.

Sharpening Your Drawing Implements

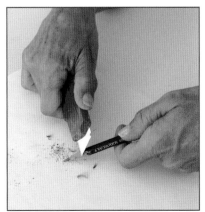

A Utility Knife can be used to form a variety of points (chiseled, blunt, or flat). Hold the knife at a slight angle to the pencil shaft, and always sharpen away from you, taking off a little wood and graphite at a time.

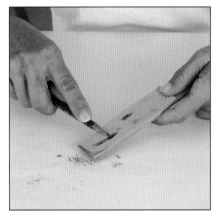

A Sandpaper Block will quickly hone the lead into any shape you wish. The finer the grit of the paper, the more controllable the point. Roll the pencil in your fingers when sharpening to keep its shape even.

Form & Value

Drawing consists of three main elements: line, shape, and form. The shape of an object can be described with a simple one-dimensional line. The three-dimensional version of the shape is known as the object's form. In pencil drawing, variations in *value* (the relative lightness or darkness of black or a color) describe *form*, giving an object the illusion of depth. In pencil drawing, values range from black (the darkest value) through different shades of gray to white (the lightest value). To make a two-dimensional object appear three-dimensional, you must pay attention to the values of the highlights and shadows. When shading a subject, consider the light source, as this is what determines where highlights and shadows will be.

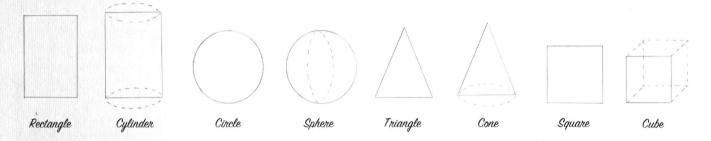

Rectangle Cylinder Circle Sphere Triangle Cone Square Cube

Moving from Shape to Form The first step in creating an object is establishing a line drawing or outline to delineate the flat area that the object takes up. This is known as the "shape" of the object. The four basic shapes—the rectangle, circle, triangle, and square—can appear to be three-dimensional by adding a few carefully placed lines that suggest additional planes. By adding ellipses to the rectangle, circle, and triangle, you've given the shapes dimension and have begun to produce a form within space. Now the shapes are a cylinder, sphere, and cone. Add a second square above and to the side of the first square, connect them with parallel lines, and you have a cube.

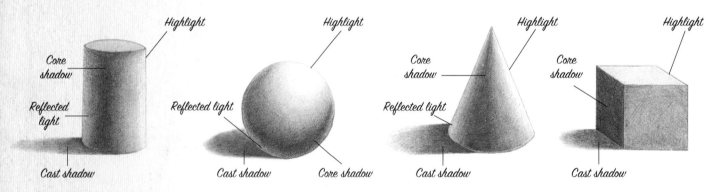

Adding Value to Create Form A shape can be further defined by showing how light hits the object to create highlights and shadows. Note from which direction the source of light is coming; then add the shadows accordingly. The core shadow is the darkest area on the object and is opposite the light source. The cast shadow is what is thrown onto a nearby surface by the object. The highlight is the lightest area on the object, where the reflection of light is strongest. Reflected light is the surrounding light reflected into the shadowed area of an object.

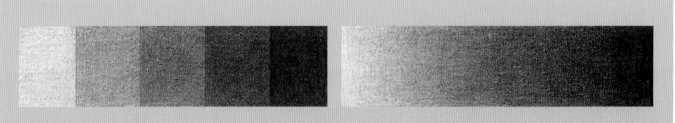

Creating Value Scales Just as a musician uses a musical scale to measure a range of notes, an artist uses a value scale to measure changes in value. You can refer to the value scale so you'll always know how dark to make your dark values and how light to make your highlights. The scale also serves as a guide for transitioning from lighter to darker shades. Making your own value scale will help familiarize you with the different variations in value. Work from light to dark, adding more and more tone for successively darker values (as shown above left). Then create a blended value scale (as shown above right). You can use a tortillon to smudge and blend each value into its neighboring value from light to dark to create a gradation.

Basic Drawing Techniques

You can create a variety of effects, lines, and strokes with pencil simply by alternating hand positions and shading techniques. Many artists use two main hand positions for drawing. The writing position is good for detailed work that requires hand control. The underhand position allows for a freer stroke with arm movement and motion that is similar to painting.

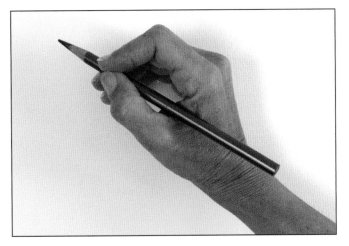

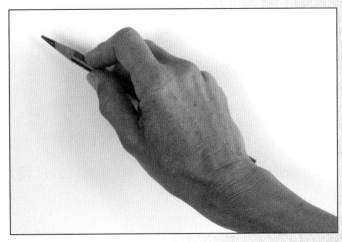

The Writing Position The writing position provides the most control in which to produce accurate, precise lines for rendering fine details and accents. When your hand is in this position, place a clean sheet of paper under it to prevent smudging.

The Underhand Position Place your hand over the pencil and grasp it between the thumb and index finger. Allow your other fingers to rest alongside the pencil. This position is great for creating beautiful shading effects and long, sweeping lines.

Shading Techniques

The shading techniques below can help you learn to render everything from a smooth complexion and straight hair to shadowed features and simple backgrounds. Whatever techniques you use, always remember to shade evenly.

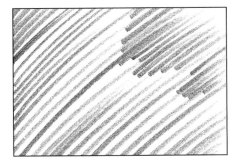

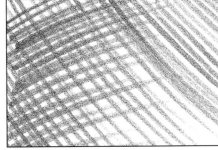

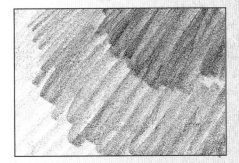

Hatching This basic method of shading involves filling an area with a series of parallel strokes. The closer the strokes, the darker the tone.

Crosshatching For darker shading, place layers of parallel strokes on top of one another at varying angles. Again, make darker values by placing the strokes closer together.

Gradating To create graduated values (from dark to light), apply heavy pressure with the side of your pencil, gradually lightening the pressure as you stroke.

Shading Darkly By applying heavy pressure to the pencil, you can create dark, linear areas of shading.

Shading with Texture For a mottled texture, use the side of the pencil tip to apply small, uneven strokes.

Blending To smooth out the transitions between strokes, gently rub the lines with a tortillon or tissue.

Practicing Lines

When drawing lines, it is not necessary to always use a sharp point. In fact, sometimes a blunt point may create a more desirable effect. When using larger lead diameters, the effect of a blunt point is even more evident. Play around with your pencils to familiarize yourself with the different types of lines they can create. For more about the different types of drawing pencils, see page 7.

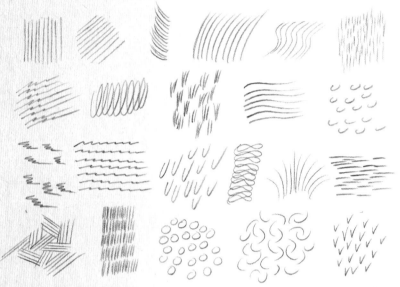

Drawing with a Sharp Point The lines at left were drawn with a sharp point. Draw parallel, curved, wavy, and spiral lines; then practice varying the weight of the lines as you draw. Os, Vs, and Us are some of the most common alphabet shapes used in drawing.

Drawing with a Blunt Point The shapes at right were drawn using a blunt point. Note how the blunt point produced different images. You can create a blunt point by rubbing the tip of the pencil on a sandpaper block or on a rough piece of paper.

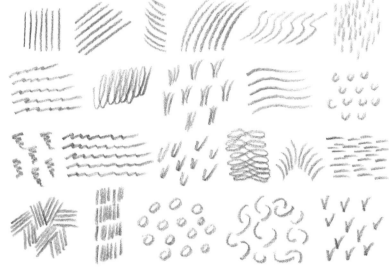

"Painting" with Pencil

When you use painterly strokes, your drawing will take on a new dimension. Think of your pencil as a brush and allow yourself to put more of your arm into the stroke. The larger the lead, the wider the stroke; the softer the lead, the more painterly the effect. The examples shown here were drawn on smooth paper with a 6B pencil, but you can experiment with rough paper for more broken effects.

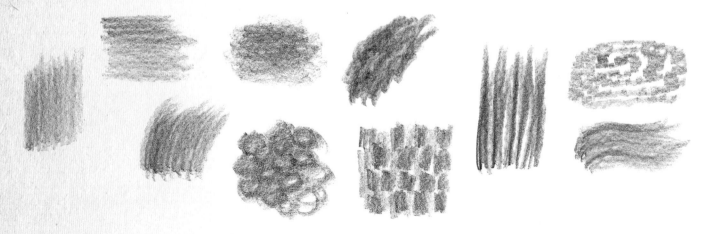

Finding Your Style

Many great artists of the past can now be identified by their unique experiments with line. Vincent van Gogh's drawings were a feast of calligraphic lines; Seurat became synonymous with pointillism; and Giacometti was famous for his scribble. Can you find your identity in a pencil stroke?

Using Criss-Crossed Strokes
If you like a lot of fine detail, you'll find that crosshatching allows you a lot of control (see page 9). You can adjust the depth of your shading by changing the distance between your strokes.

Sketching Circular Scribbles
If you work with round, loose strokes, you are probably experimental with your art. These looping lines suggest a free-form style that is more concerned with evoking a mood than with capturing precise details.

Drawing Small Dots This technique, called "stippling," uses many small dots to create a larger picture. Make the points different sizes to create various depths and shading effects.

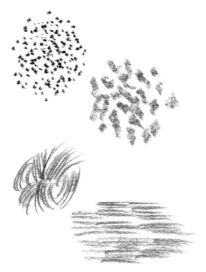

Simulating Brushstrokes
You can create the illusion of brushstrokes by using short, sweeping lines. These strokes are ideal for a more stylistic approach.

Working with Different Techniques

Below are several more techniques that can be created with pencil. You will need both soft and hard pencils for these exercises.

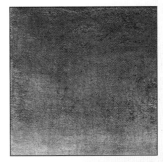

Creating Washes First shade an area with a water-soluble pencil. (This is a pencil that produces washes similar to watercolor paint when manipulated with water.) Blend the shading with a wet brush. Make sure your brush isn't too wet, and use thick paper, such as vellum board.

Rubbing Place paper over an object and rub the side of your pencil lead over the paper. The strokes of your pencil will pick up the pattern underneath and replicate it on the paper. Try using a soft pencil on smooth paper, and choose an object with a strong textural pattern, such as a wire grid, as shown at left.

Lifting Out Blend a soft pencil on smooth paper, and then lift out the desired area with a kneaded eraser. You can create highlights and other interesting effects with this technique.

Producing Indented Lines
"Draw" a pattern or design with a sharp, non-marking object such as a knitting needle. Next, shade over the area with the side of your pencil to reveal the pattern.

Smudging

Smudging is an important technique for creating shading and gradients. Use a tortillon or chamois cloth to blend your strokes. It is important that you do not use your finger, because your hand has natural oils that can damage your art.

Smudging on Rough Surfaces
For a granular effect, use a 6B pencil on vellum-finish Bristol board. Stroke with the side of the pencil; then blend with a tortillon.

Smudging on Smooth Surfaces
Use a 4B pencil on plate-finish Bristol board. Stroke with the side of the pencil; then blend with a tortillon.

People in Perspective

To practice perspective, try drawing a frontal view of many heads as if they were people sitting in a theater. Start by establishing your vanishing point at eye level. Draw one large head representing the person closest to you, and use it as a reference for determining the sizes of the other figures in the drawing. Keep in mind that a composition also can have two or more vanishing points.

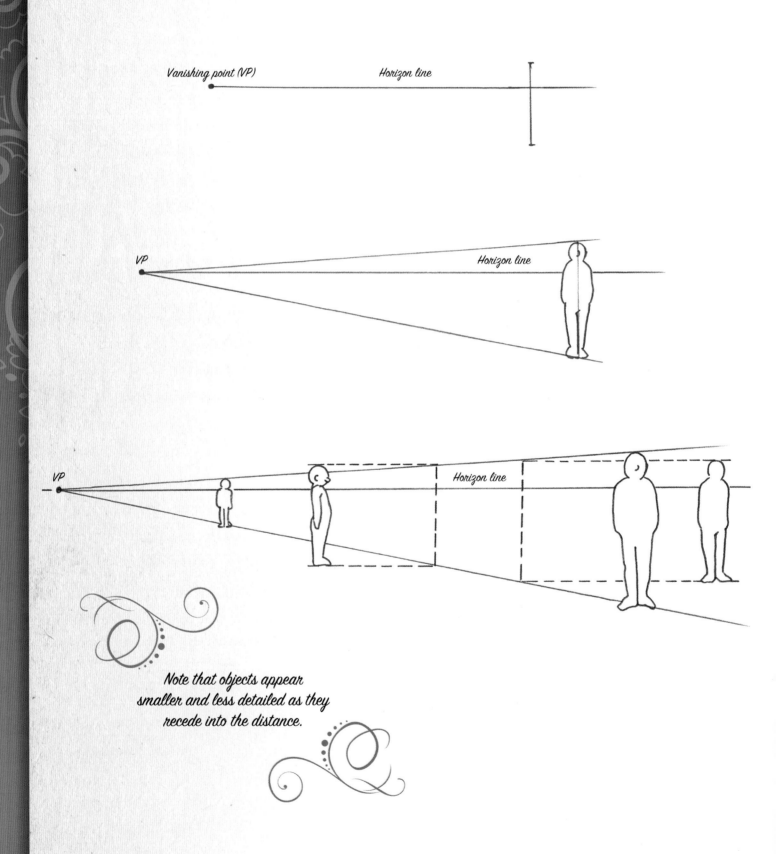

Note that objects appear smaller and less detailed as they recede into the distance.

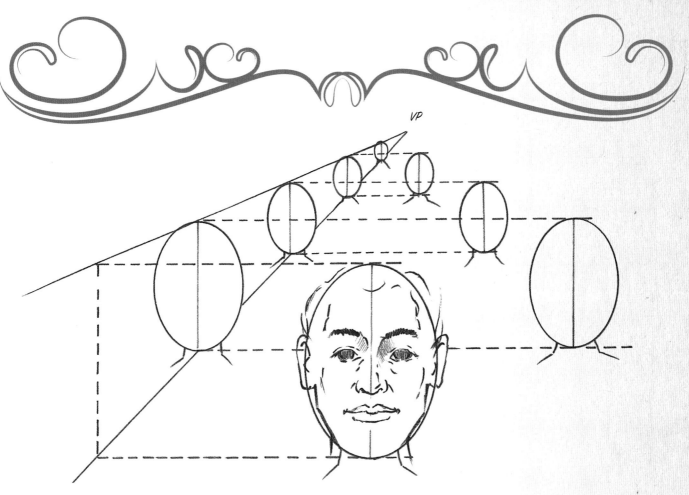

If you're a beginner, you may want to begin with basic one-point perspective. As you progress, attempt to incorporate two- or three-point perspective.

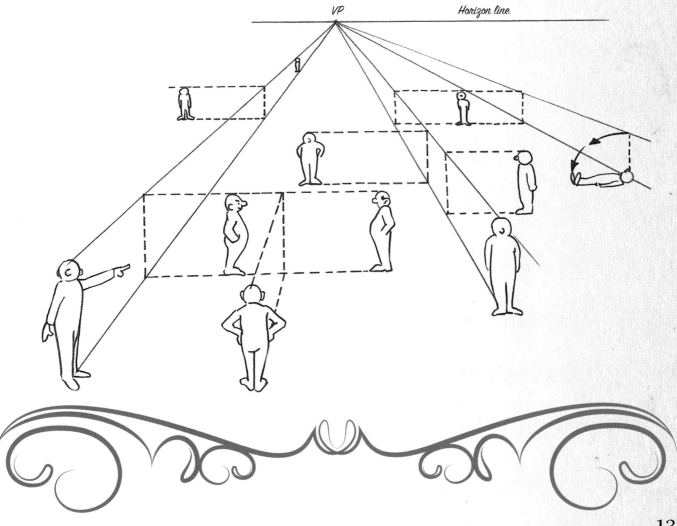

Basics of Portraiture

The positioning and size of a person on the *picture plane* (the physical area covered by the drawing) is of utmost importance to the *composition*, or the arrangement of elements on your paper. The open, or *negative*, space around the subject generally should be larger than the area occupied by the subject, providing a sort of personal space surrounding it. Whether you are drawing only the face, a head-and-shoulders portrait, or a complete figure, thoughtful positioning will establish a pleasing composition with proper balance. Practice drawing thumbnail sketches of people to study the importance of size and positioning.

Correct Placement

Correct placement on the picture plane is key to a good portrait. Avoid drawing too near to the sides, top, or bottom of the picture plane, as this lends to a sense of imbalance.

Too far right

Too low

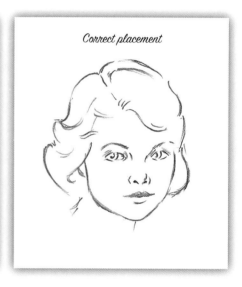

Correct placement

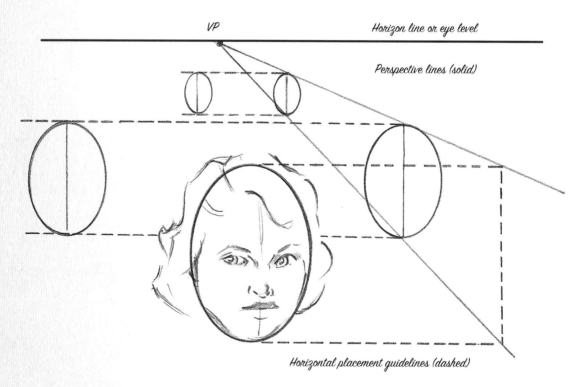

VP *Horizon line or eye level*

Perspective lines (solid)

Horizontal placement guidelines (dashed)

Multiple Subjects If you are drawing several, similarly sized subjects, use the rules of perspective to determine relative size (see pages 12-13). Draw a vanishing point on a horizon line and a pair of perspective lines. Receding guidelines extended from the perspective lines will indicate head and chin placement in the composition. Notice that heads become smaller as they get farther from the viewer.

Many portraits are drawn without backgrounds to avoid distracting the viewer from the subject. If you do add background elements to a portrait, be sure to control the size, shape, and arrangement of objects surrounding the figure. Additions should express the personality or interests of the subject.

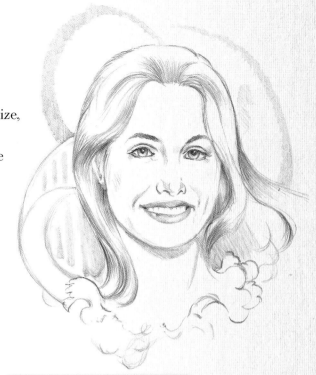

▶ *Repetition of Shapes* The delicate features of this young woman are emphasized by the simple, abstract elements in the background. The flowing curves fill much of the negative space while accenting the woman's hair and features. Simplicity of form is important in this composition: The portrait highlights only her head and neck.

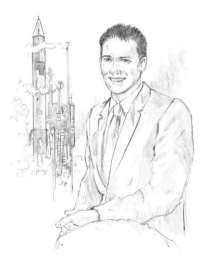

Depicting the Subject's Interest This portrait of a young man includes a background that shows his interest in rocketry. The straight lines in the background contrast with the rounded shapes of the human form. Although the background detail is complex, it visually recedes and serves to balance the subject's weight so that the focus remains on him.

Drawing Close-ups Intentionally drawing your subject larger than the image area, as in the example at left, can create a unique composition. Even if part of the image is cut off, this kind of close-up creates a dramatic mood.

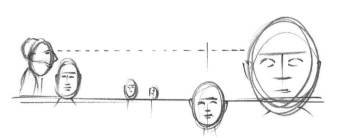

Guiding the Eye The composition above illustrates how eyesight direction and line intersection can guide the viewer's eye to a particular point of interest.

Creating Flow You can create a flow or connection between multiple subjects in a composition by creatively using circles and ellipses.

Adding Curves Curved lines are great for creating harmony and balance. Draw some curved lines around the paper, letting the empty spaces guide you with placement.

Adding Sharp Angles Sharp angles can produce dramatic compositions. Draw a few straight lines in various angles, and make them intersect at certain points. Zigzagging lines also form sharp corners that give the composition energy.

Adult Proportions

Learning the proper proportions of the human face is critical to accurately drawing it. *Proportion* is the comparative relationship among parts relative to size and placement. The examples on this page illustrate how to determine the correct size and placement of each feature. Once you know these basics, you can modify them to achieve a likeness to your subject. Remember that differences in proportion are what make each person unique.

Sketch an oval, and divide it in half horizontally and vertically with light guidelines, as shown at right. On an adult, the eyes fall on the horizontal center line, usually about one eye-width apart. The nose is located on the vertical center line. Study the diagrams to learn the proportions and placements of all the features.

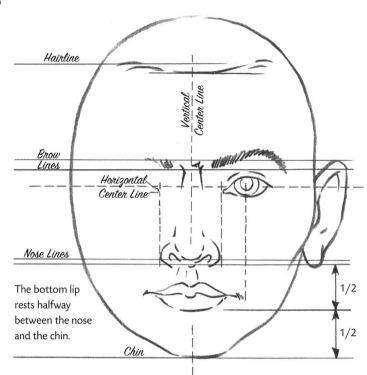

Hairline

Vertical Center Line

Brow Lines

Horizontal Center Line

Nose Lines

The bottom lip rests halfway between the nose and the chin.

Chin

1/2

1/2

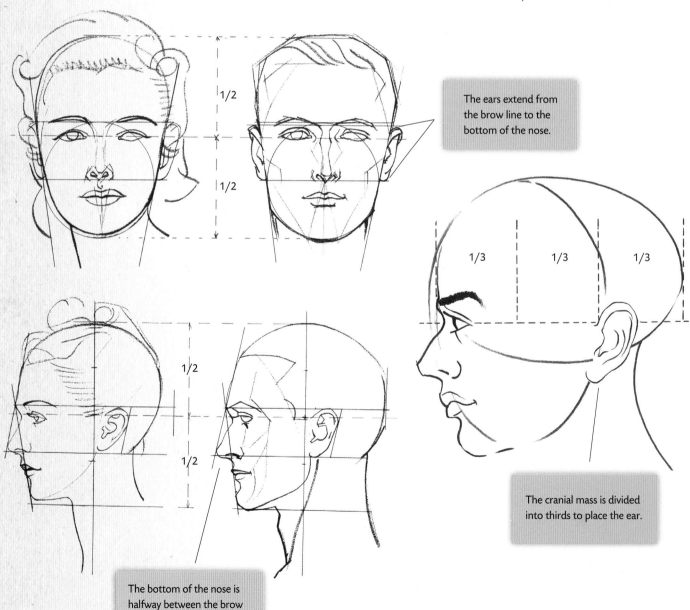

1/2

1/2

The ears extend from the brow line to the bottom of the nose.

1/3 1/3 1/3

1/2

1/2

The bottom of the nose is halfway between the brow and the bottom of the chin.

The cranial mass is divided into thirds to place the ear.

16

Children's Proportions

The proportions of a child's head differ from those of an adult. For example, children generally have larger foreheads, so the eyebrows—not the eyes—fall on the horizontal center line. Also, a youngster's eyes are usually bigger, rounder, and spaced farther apart than an adult's.

Use horizontal guidelines to divide the area from the brow line to the chin into four equal sections. Use these lines to determine eye, nose, and mouth placement., as shown below.

Infant

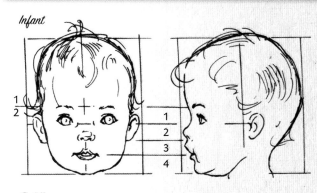

Toddler

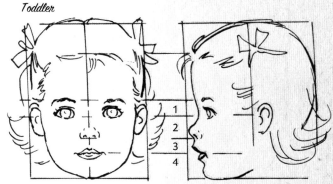

As children get older, their faces become longer, and the facial proportions change accordingly.

Six-year-old

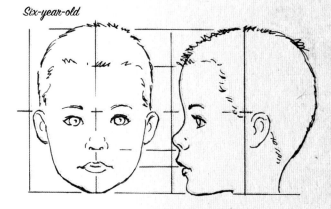

Notice that, as the face becomes longer and narrower, the chin becomes more square, and the eyes appear smaller.

Ten-year-old

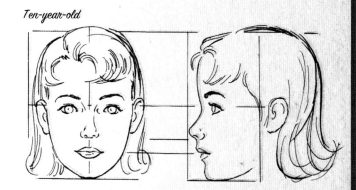

Brow Line

Eye Line

Dividing the forehead vertically into five equal sections can help you keep the facial features balanced.

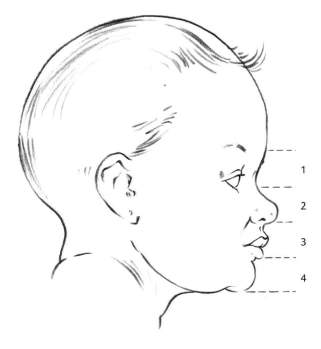

A child's forehead protrudes farther than an adult's and the hairline starts much higher.

17

Adult Features

If you are a beginner, practice drawing the facial features separately so you can work out any issues before attempting a finished drawing.

Noses

Block in the basic shape of the nose with simple lines as illustrated below; then refine the lines into subtle curves, according to the shape of the individual's nose.

Ears

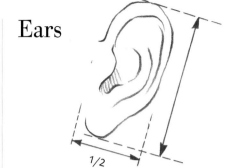

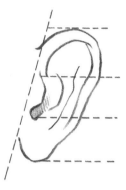

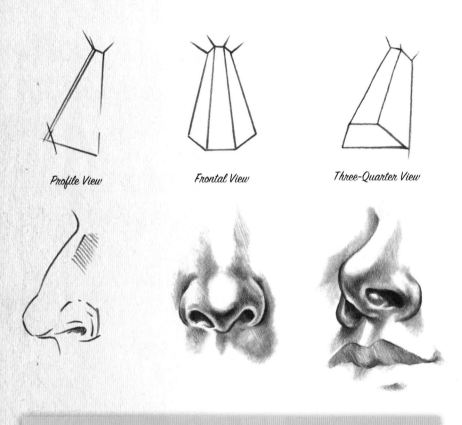

Profile View *Frontal View* *Three-Quarter View*

As shown above, the ears usually connect to the head at a slight angle. Notice that the width of the ear is about one-half its length. The ear can be divided into three horizontal sections, which make it easier to see its basic shapes and ridges.

When shading the nose, don't make the nostrils too dark. Generally, men's nostrils are angular and women's nostrils are more curved.

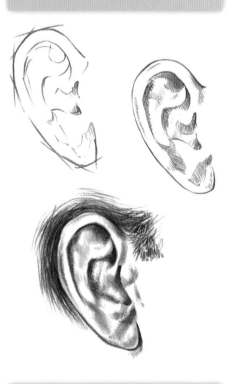

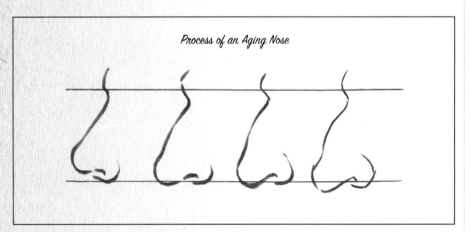

Process of an Aging Nose

The diagram above shows how the nose changes as a person grows older. These details are important for producing realistic works.

To draw the ear, block in the general shape and lightly sketch the ridges (step 1). Begin shading the ridges to develop the form (step 2). Finally, add the darkest values to complement the highlights.

Eyes

The eyes are the most important feature for achieving a likeness to your subject. They also play a large part in communicating the person's mood or emotion. You can become skilled at drawing eyes by practicing the examples on this page.

After blocking in the basic shapes, begin shading to create the form. Pay attention to the planes of the face around the eyes. The shading should indicate the eyes' depth and indentation into the face. A sharp pencil is useful for creating the creases and corners. As you move away from the eyes, shading should gradually lighten.

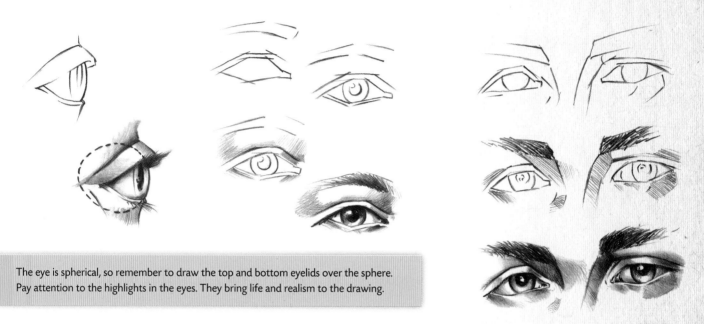

The eye is spherical, so remember to draw the top and bottom eyelids over the sphere. Pay attention to the highlights in the eyes. They bring life and realism to the drawing.

Lips

When drawing lips, familiarize yourself with their various planes. And when shading, pay attention to the location of the highlights, which enhance fullness and form.

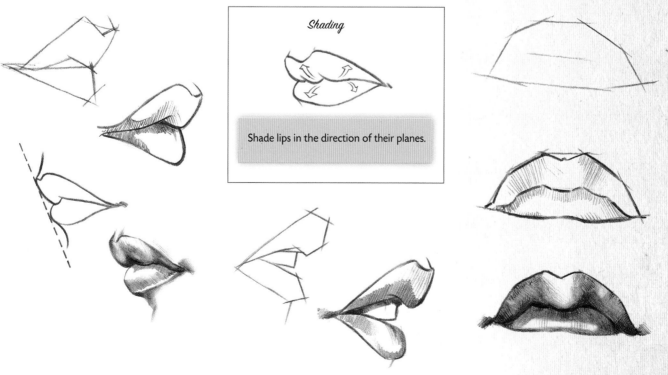

Shading

Shade lips in the direction of their planes.

19

Children's Features

In general, children's faces and features are smoother, rounder, and, of course, smaller; therefore, shading should be minimal and light.

Ears and Noses

As the illustrations below show, first lightly block in the basic shape of the ear and nose; then further develop them with shading.

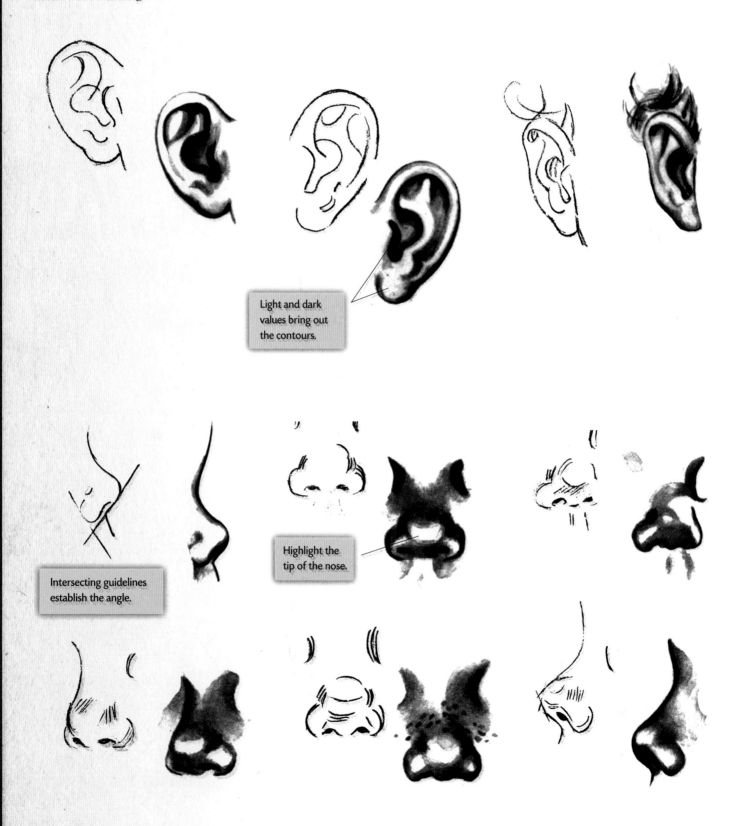

Light and dark values bring out the contours.

Intersecting guidelines establish the angle.

Highlight the tip of the nose.

Eyes

Children's eyes usually appear rounder than an adult's. Aim to create a soft, innocent expression by keeping your lines and shading delicate. Adding highlights in the pupils will add life to your drawing.

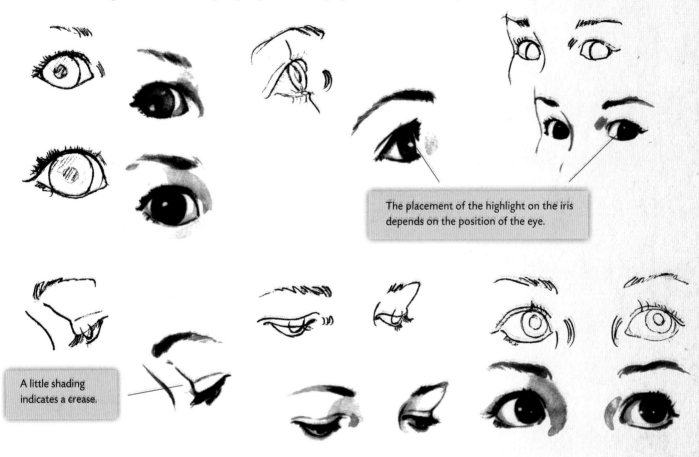

The placement of the highlight on the iris depends on the position of the eye.

A little shading indicates a crease.

Lips

Children's lips have a soft appearance. Highlights are important for conveying the smooth texture.

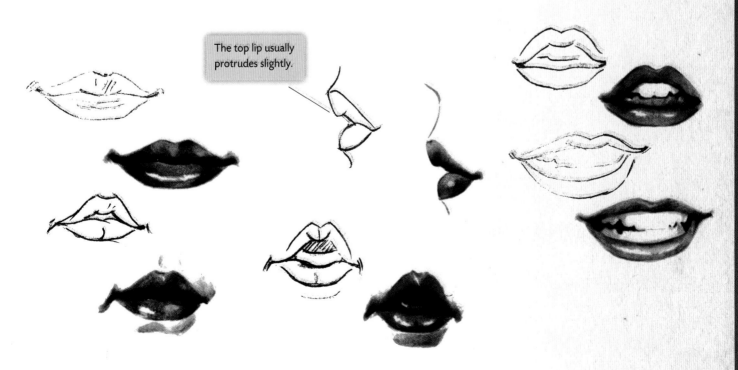

The top lip usually protrudes slightly.

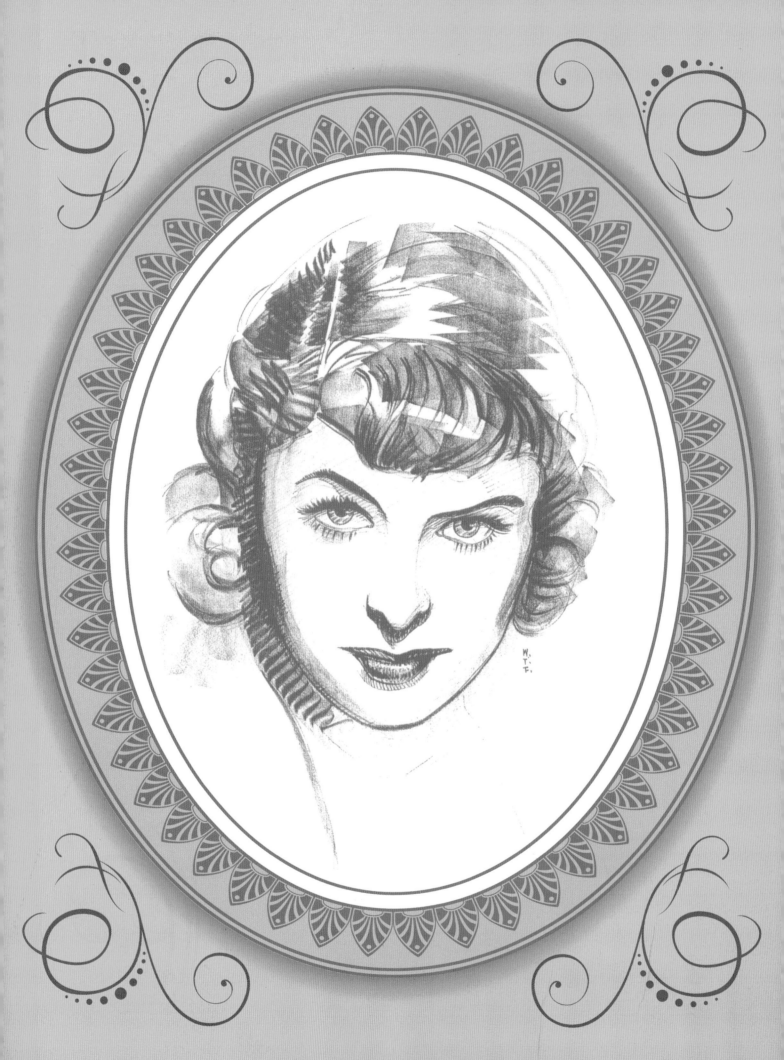

Chapter 2:
Men & Women

Once you have familiarized yourself with the rules of proportion and the specific characteristics of each facial feature, you will be ready to try your hand at drawing the head in its entirety. We will start with the profile, or side view, as it is the least challenging angle and the best way for helping you to become accustomed with the correct placement of the features. Once you have completed these drawings, you will be ready to tackle frontal and three-quarter views of the head. These angles are more complex because they require more precise shading and careful attention to detail. As you work your way through the projects in this chapter, be sure to refer to previous sections of the book to ensure that your proportions are accurate and that your facial features are realistic. With practice and dedication, you will master these fundamentals!

Profile View

Once you have practiced drawing each facial feature separately, you can combine your skills to draw the entire head in different positions. Start with a simple profile that requires minimal shading.

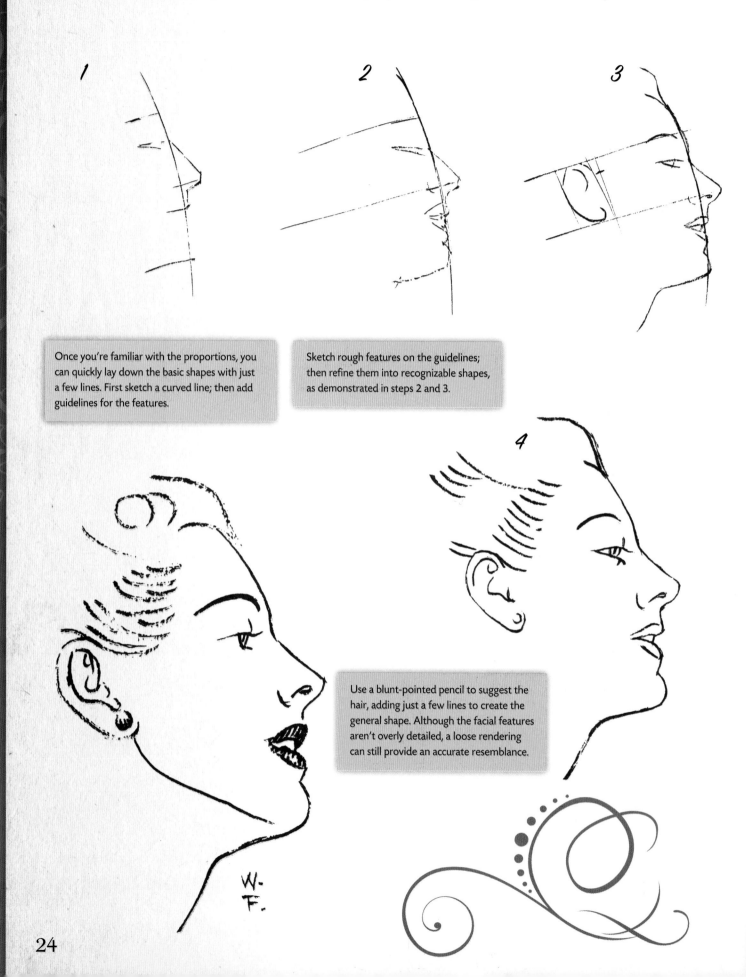

1

Once you're familiar with the proportions, you can quickly lay down the basic shapes with just a few lines. First sketch a curved line; then add guidelines for the features.

2

Sketch rough features on the guidelines; then refine them into recognizable shapes, as demonstrated in steps 2 and 3.

3

4

Use a blunt-pointed pencil to suggest the hair, adding just a few lines to create the general shape. Although the facial features aren't overly detailed, a loose rendering can still provide an accurate resemblance.

W. F.

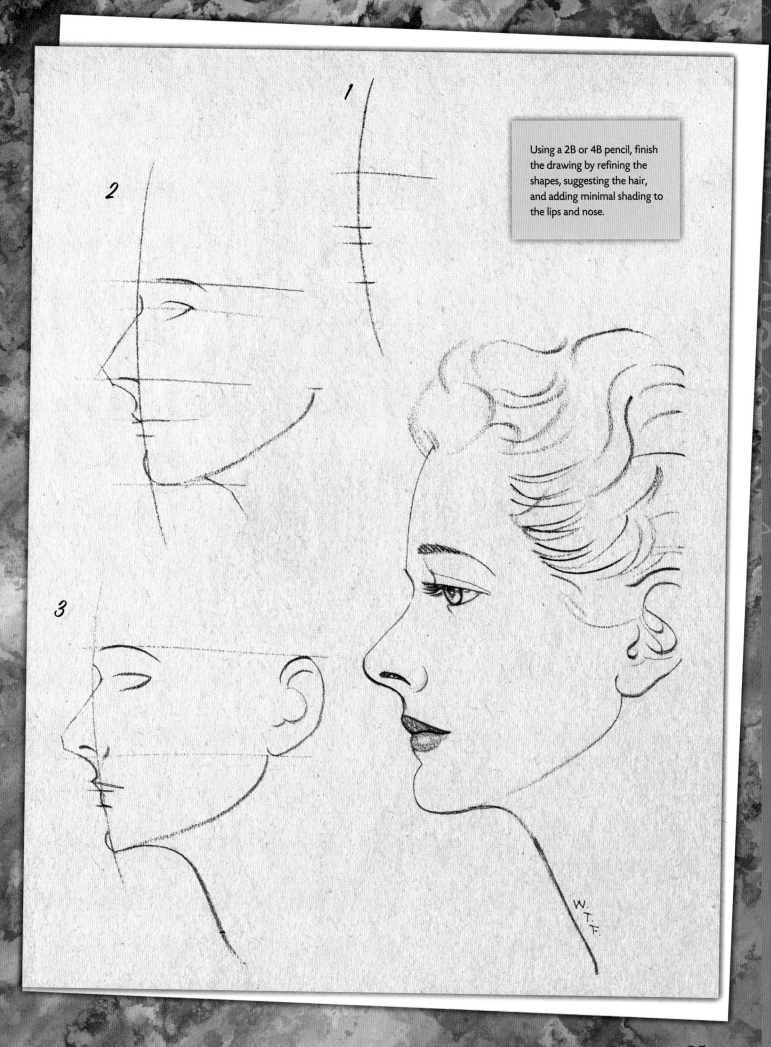

Using a 2B or 4B pencil, finish the drawing by refining the shapes, suggesting the hair, and adding minimal shading to the lips and nose.

W.
T.
F.

Drawing profiles is an excellent way for learning to master facial features. Pay attention to the shapes of the nose and chin; these features will greatly affect the overall appearance.

Begin with a slightly curved vertical line and add guidelines according to the proportions; then lightly block in the features (step 1) and refine the shapes (step 2). Study your subject's features carefully. Are the eyes bright or dull? Is the nose long or short? Are the lips thin or full? These factors help determine how to achieve a true likeness.

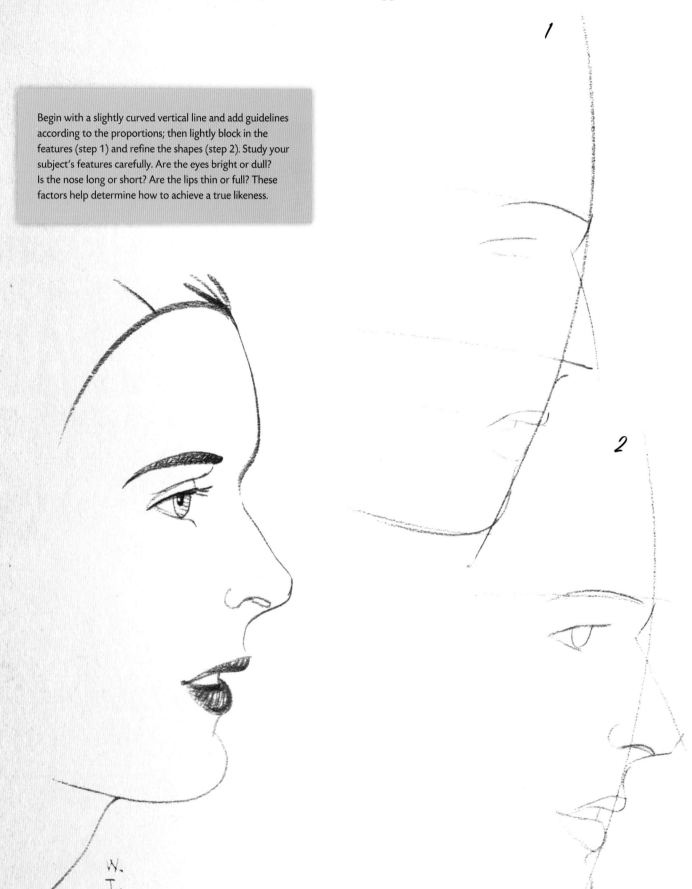

B y now you should be able to create a strong rendering using simple lines. In this drawing, contour shading makes the subject appear much more realistic.

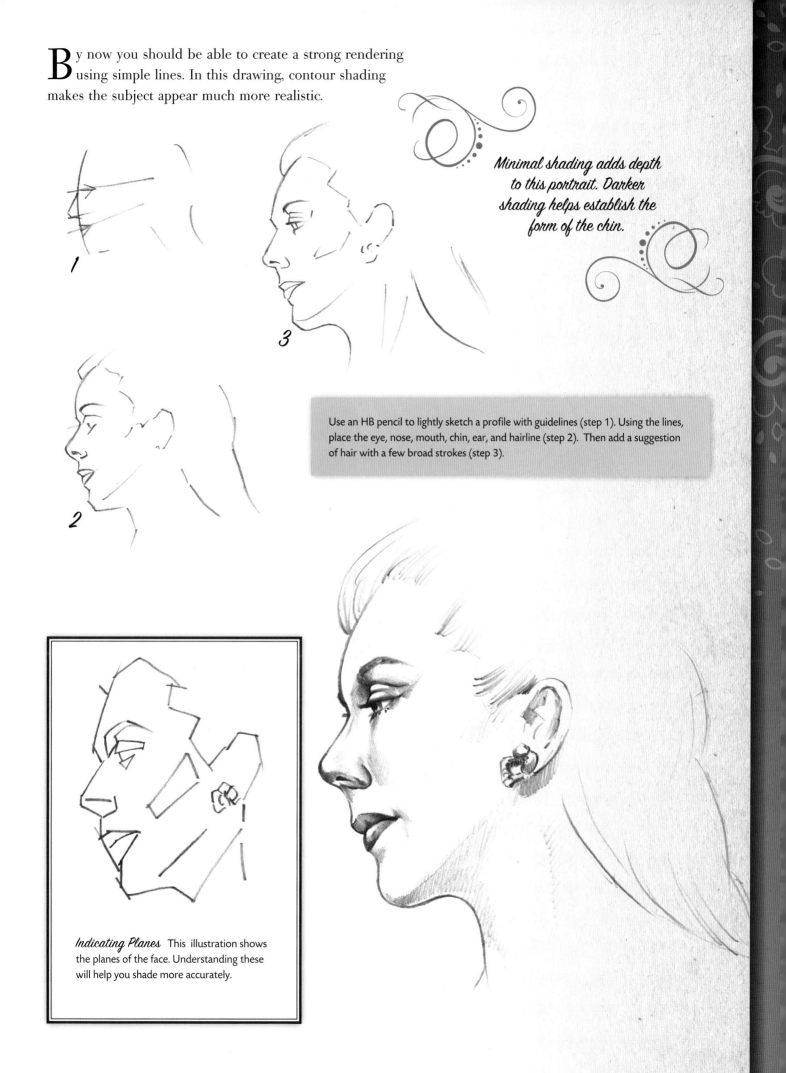

Minimal shading adds depth to this portrait. Darker shading helps establish the form of the chin.

Use an HB pencil to lightly sketch a profile with guidelines (step 1). Using the lines, place the eye, nose, mouth, chin, ear, and hairline (step 2). Then add a suggestion of hair with a few broad strokes (step 3).

Indicating Planes This illustration shows the planes of the face. Understanding these will help you shade more accurately.

Sometimes it is useful to work from photographs when you are just learning to draw. Don't worry about the details, such as the hair. Simply focus on your technique.

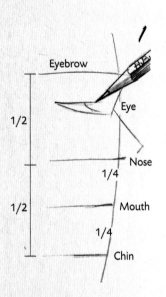

1

Eyebrow

1/2

Eye

Nose

1/4

1/2

Mouth

1/4

Chin

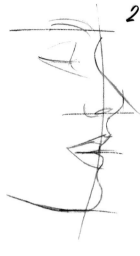

2

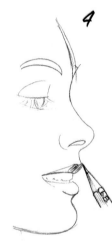

3

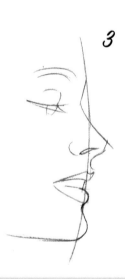

4

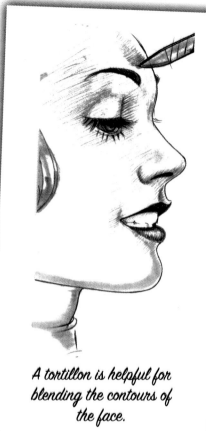

Sketch out the proportions of the face (step 1). Once you have established them, sketch in the facial features (step 2). Continue refining your drawing until you are ready to begin shading (steps 3 and 4).

A tortillon is helpful for blending the contours of the face.

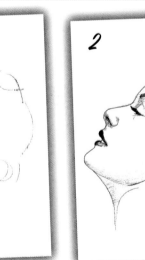

1

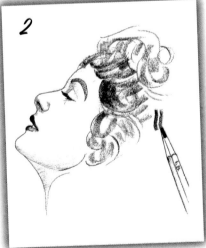

2

Not every profile needs to be drawn with the head at the same angle, but the basic steps will remain the same. First draw guidelines to establish the correct proportions; then refine the features.

Focus on the dark and light values and the direction of the strokes. Note that the hair is merely implied as a surrounding element.

Keep shading lighter toward the middle of the lips to add highlights and make them appear full.

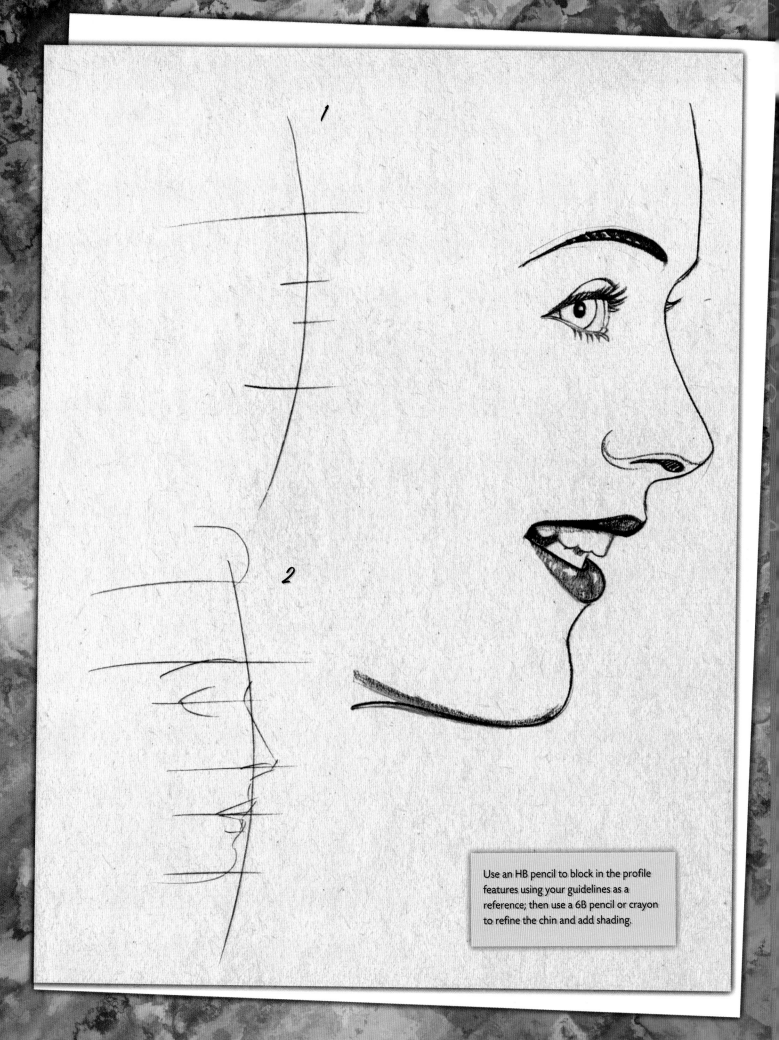

1

2

Use an HB pencil to block in the profile features using your guidelines as a reference; then use a 6B pencil or crayon to refine the chin and add shading.

Notice how this drawing starts with a few basic guidelines and slowly progresses to a finished work of art. The key to rendering a realistic likeness is to take your time when blocking in the facial features so that each part is positioned correctly and is in proportion with every other element. Notice how it only takes a few simple lines to capture a likeness.

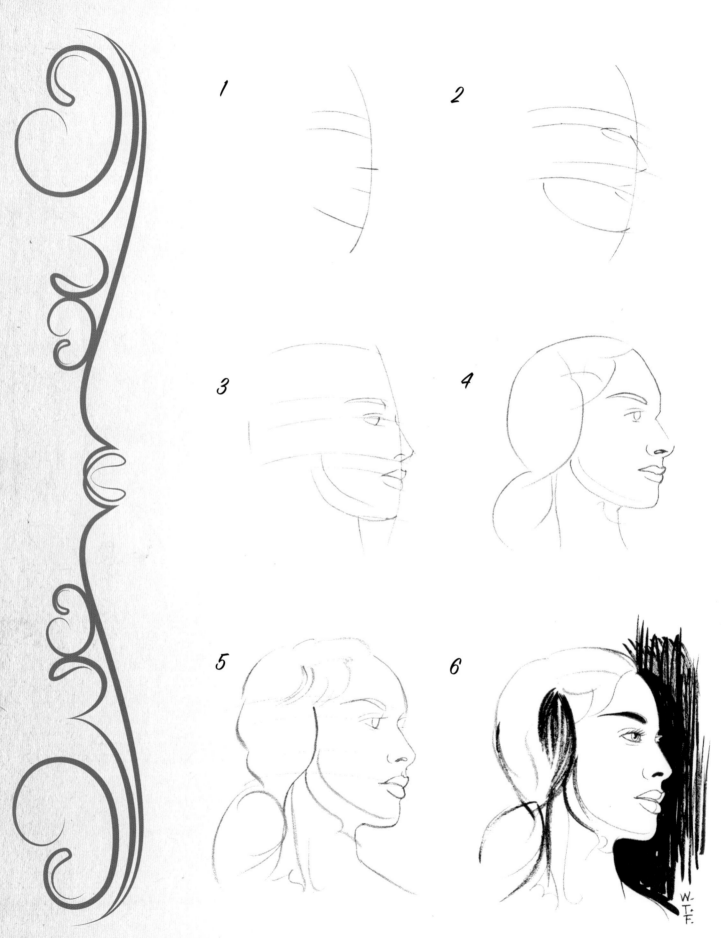

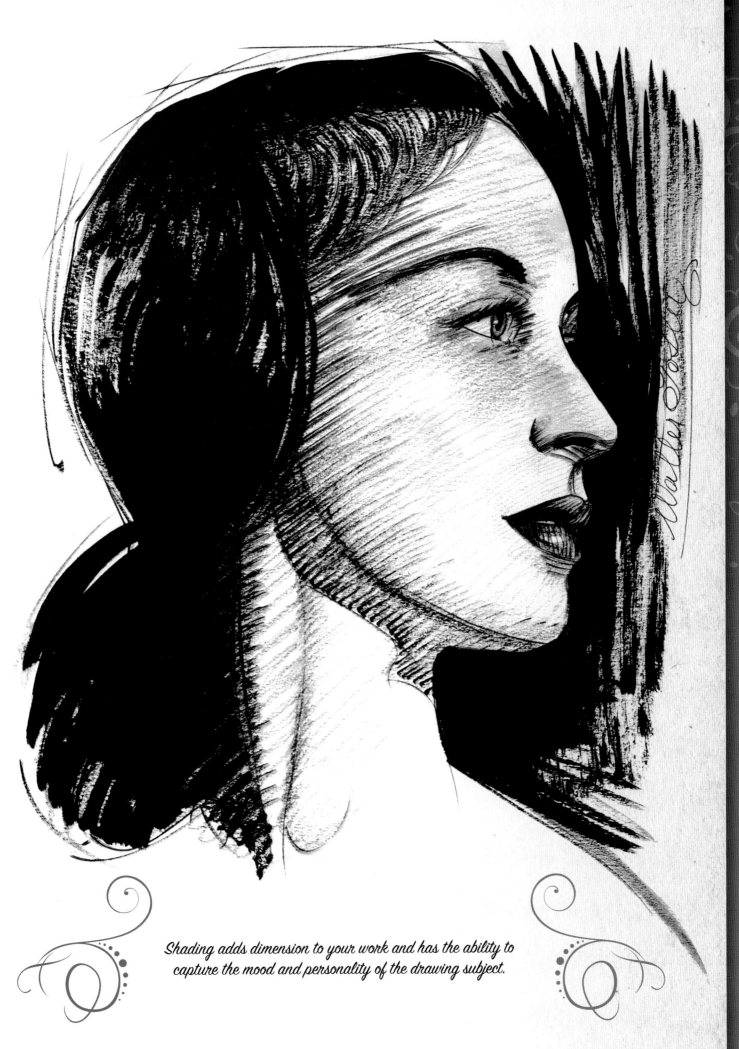

Shading adds dimension to your work and has the ability to capture the mood and personality of the drawing subject.

A drawing does not have to be complex to be good. In fact, leaving out key details—in this case the ear—or adding minimal details, such as a few wisps of hair, often adds to the authenticity of a work.

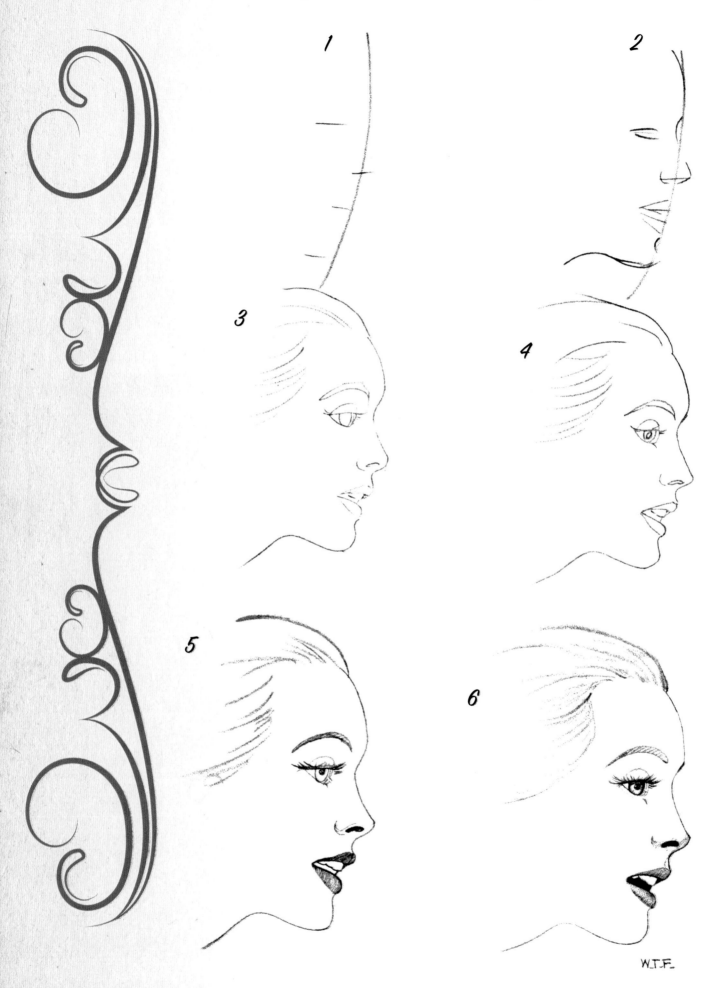

W.T.F.

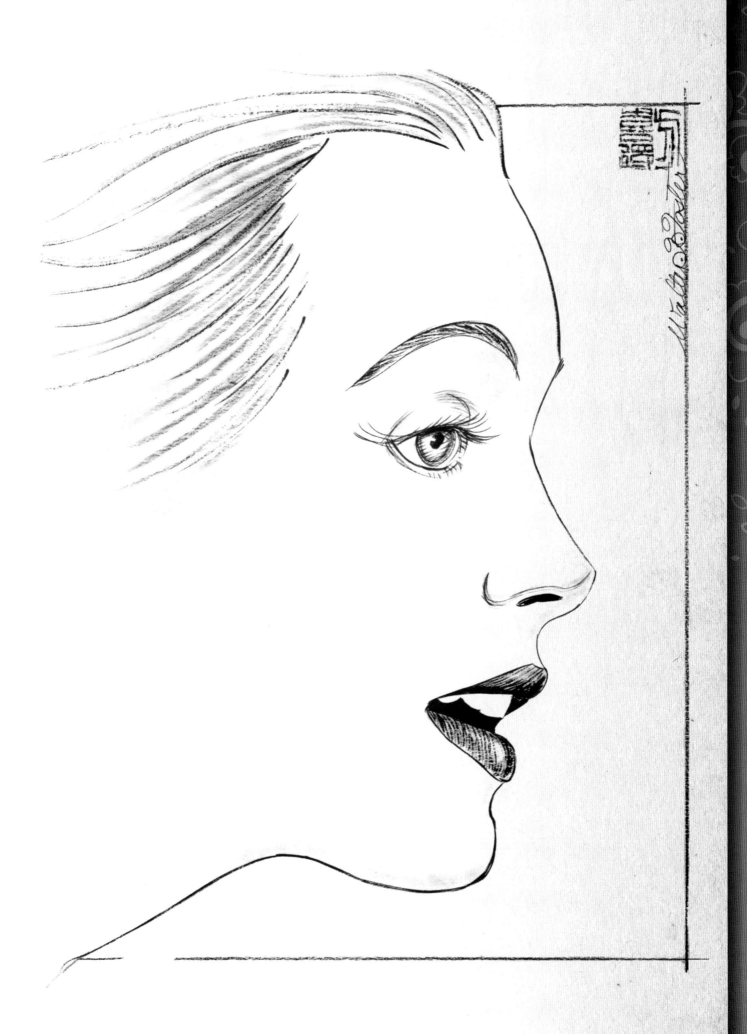

33

This subject's expression evolves slowly with each new drawing step. Even small details can have a huge impact on properly capturing your subject's expression, including a slight curve of the lips, laugh lines around the eyes and mouth, and the position of the head.

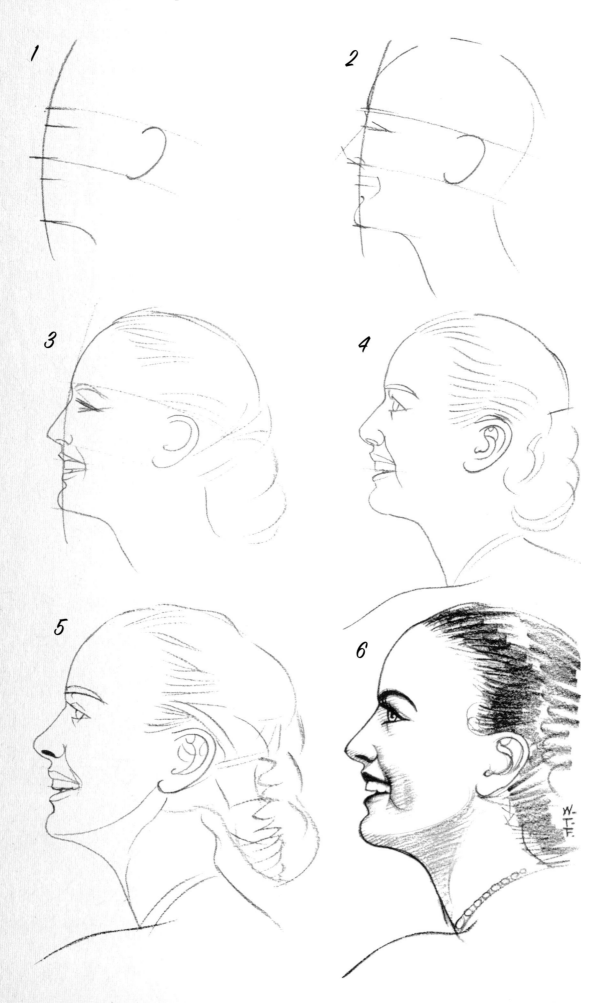

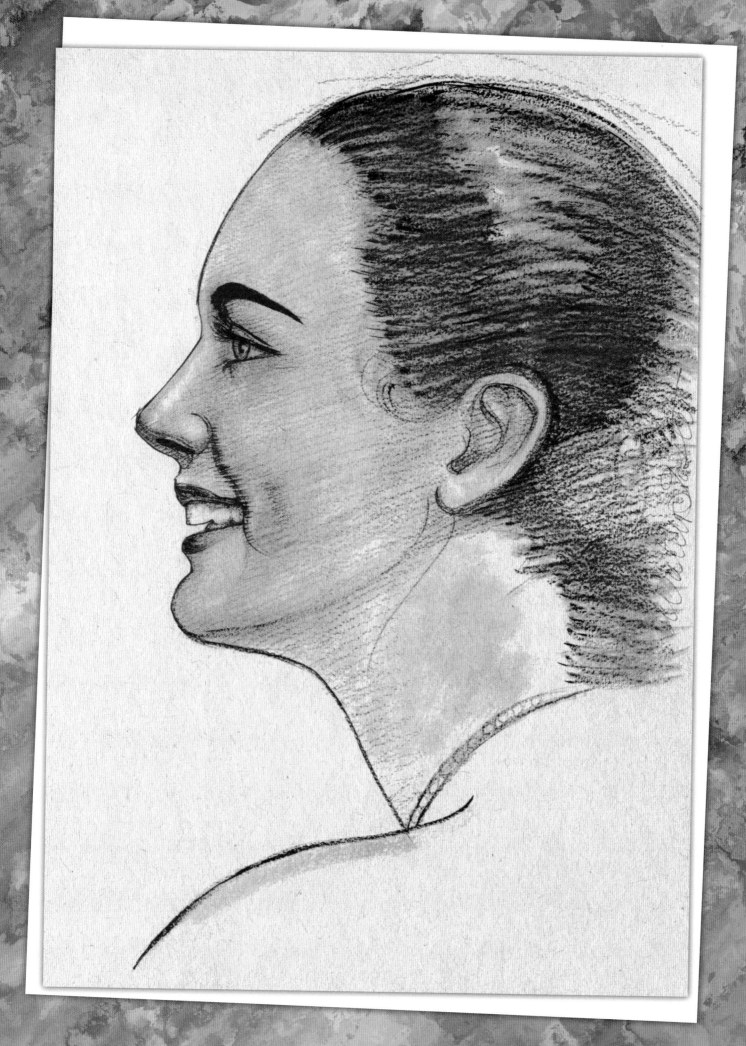

When drawing clothing, the goal is to make it appear natural. Clothing should enhance the subject's face—not draw attention away from it.

1

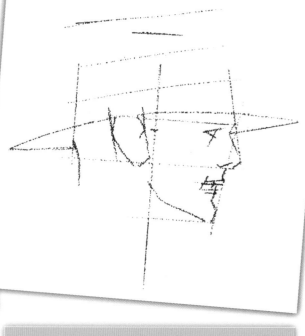

2

Start by sketching the basic proportions. Note that men generally have a stronger jawline and slightly sharper facial features than women.

Begin drawing in the hat, sketching your guidelines through it. Remember that the hat fits around the head; it doesn't sit on top of it. The top of the hat should be slightly higher than the top of the head, and the rim should cover the top of the ear.

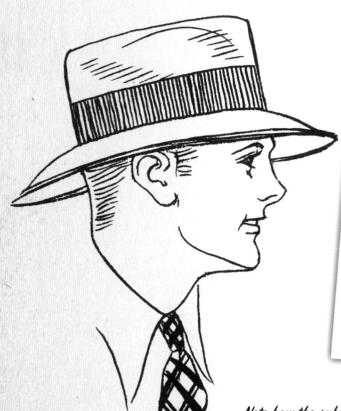

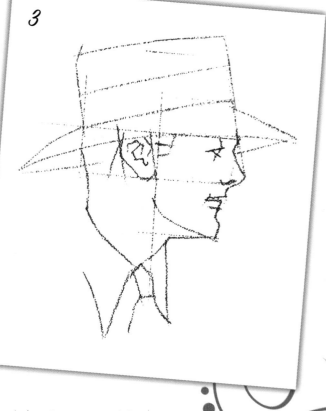

3

Note how the subject's head is at a profile, but his body is turned slightly forward. This is indicated by the position of the shirt and tie.

T his man is slightly older than the subject on the opposite page; the wrinkles along his face are an obvious indication. Also notice that he is turned completely at a profile, so the view of the tie, shirt, and jacket are also drawn from the side.

1

Start with guidelines to block in the facial features.

2

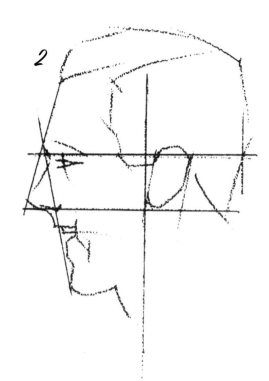

Draw in the rest of the head, continually checking your proportions.

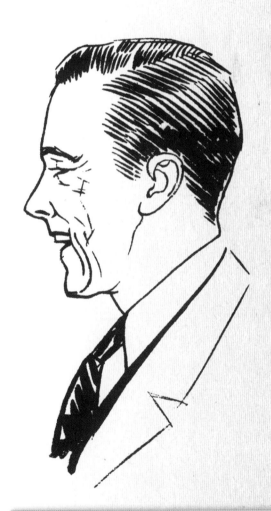

3

To create the slicked-back effect of the hair, lay down heavy hatching in the direction of the hair's growth.

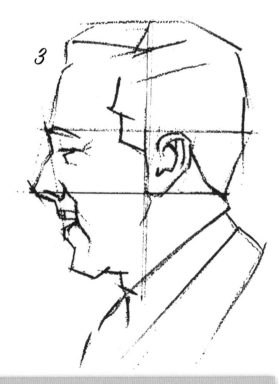

Draw the outline of the collar, tie, and jacket; then add faint lines around the mouth and eye to indicate folds in the skin.

T ry to keep structural anatomy in mind when drawing people, taking care not to make the head too large or too small. While sketching the outline of this subject's profile in step 2, I inadvertently widened the back of the head; I corrected the proportion in step 3.

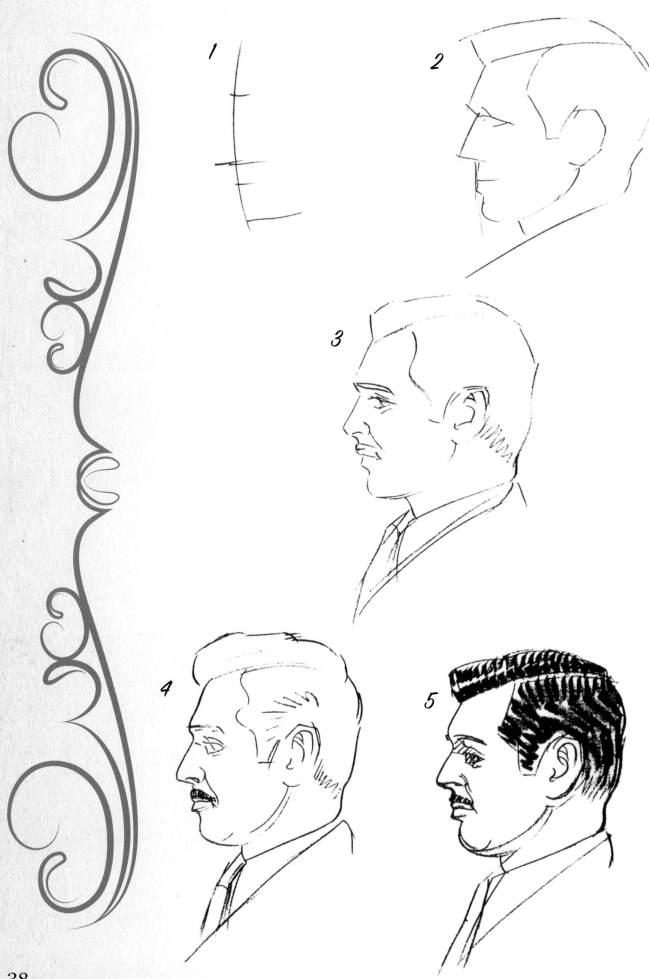

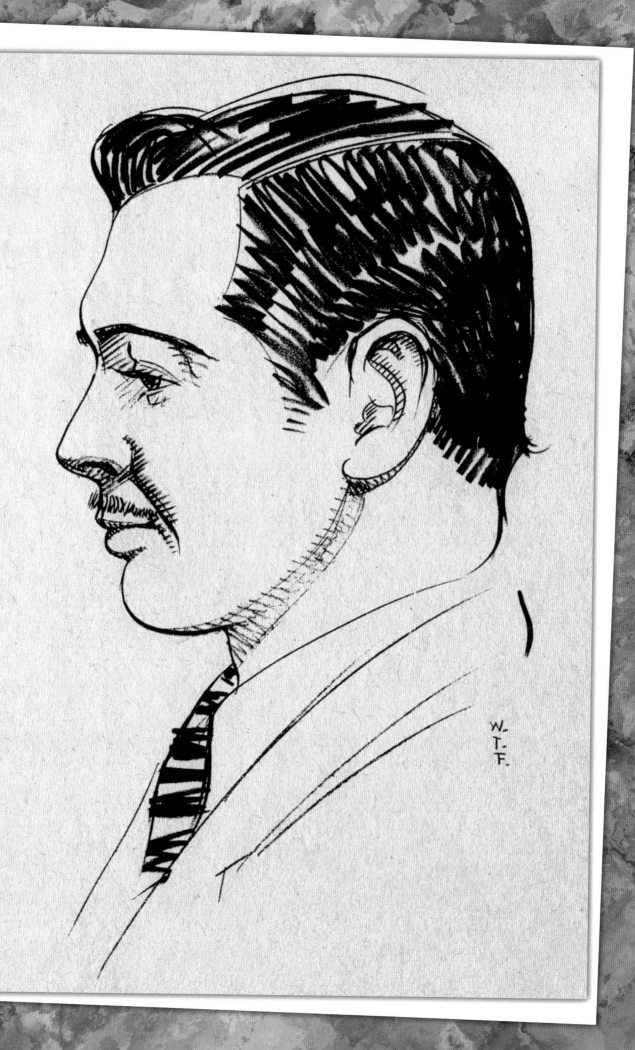

Frontal & Three-Quarter Views

Drawing a three-quarter view is slightly more difficult than drawing a profile or frontal view. Because the face is angled, the features are all set off center, with the nose at a three-quarter point. Curve the line for the bridge of the nose all the way out to the edge of the face, so it partially blocks the subject's left eye.

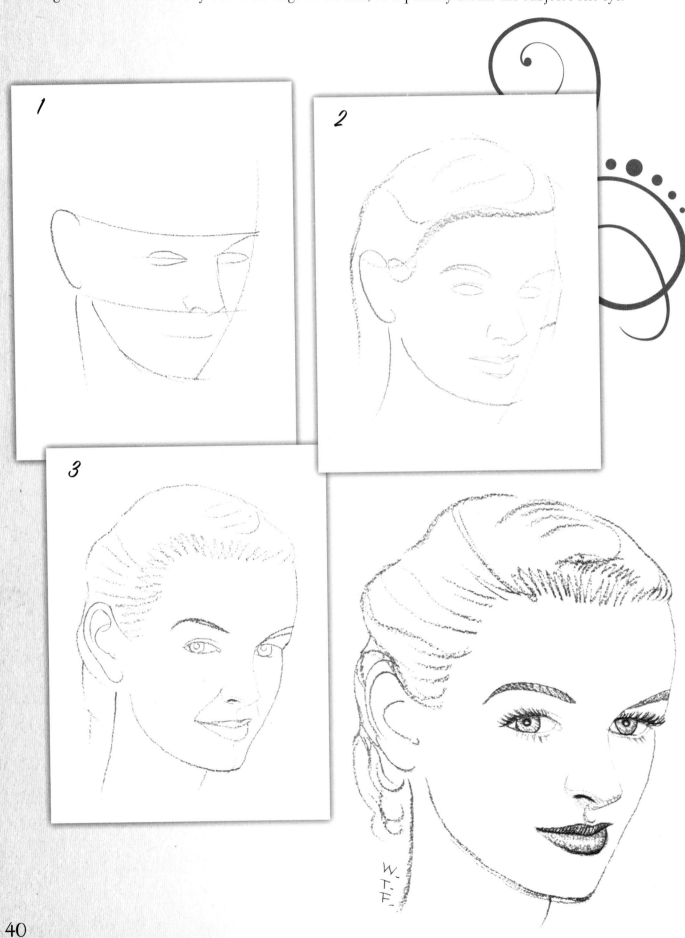

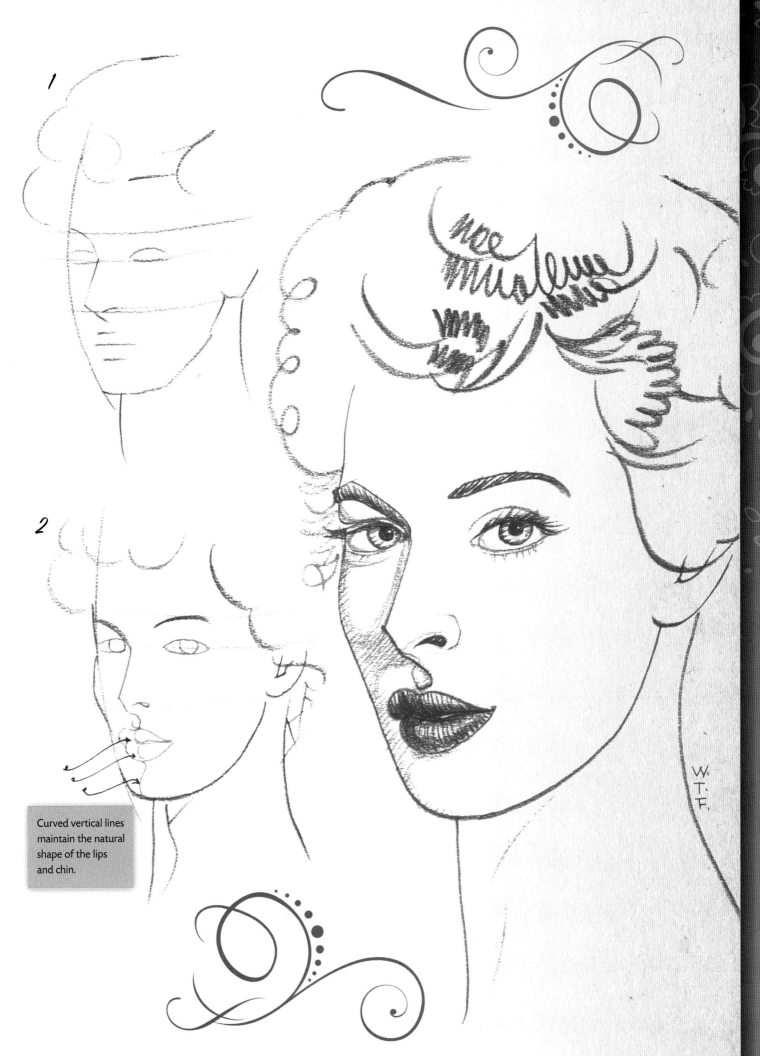

1

2

Curved vertical lines maintain the natural shape of the lips and chin.

W. T. F.

41

Creating quick sketches like the ones on this and the opposite page are a great way for you to practice your technique. Feel free to experiment with developing your own personal style. Doing so will enhance your skills and make your drawings stand out.

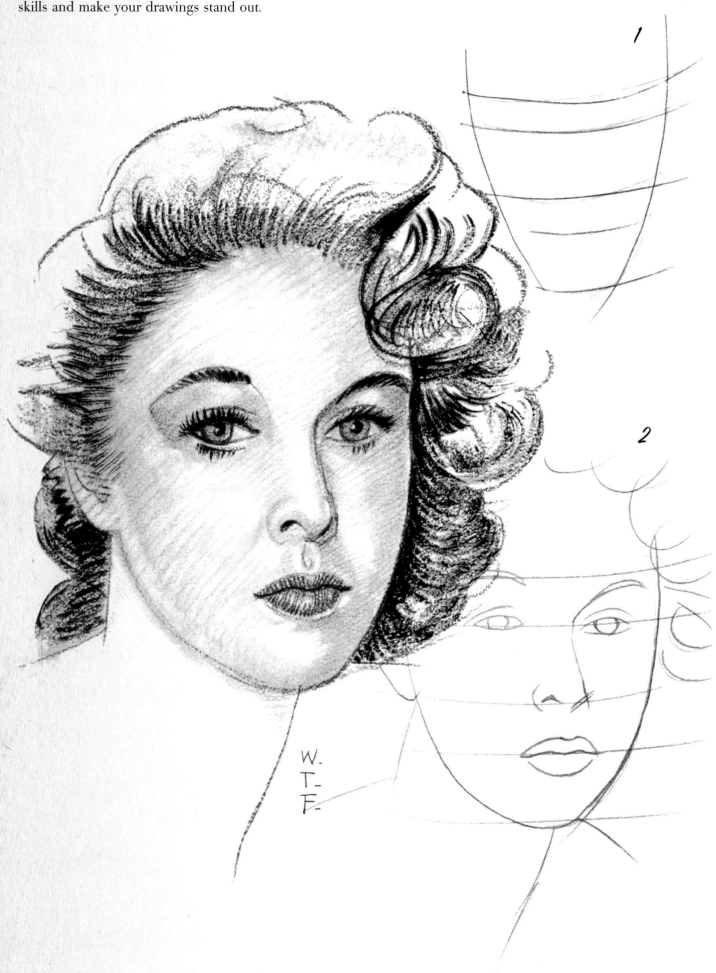

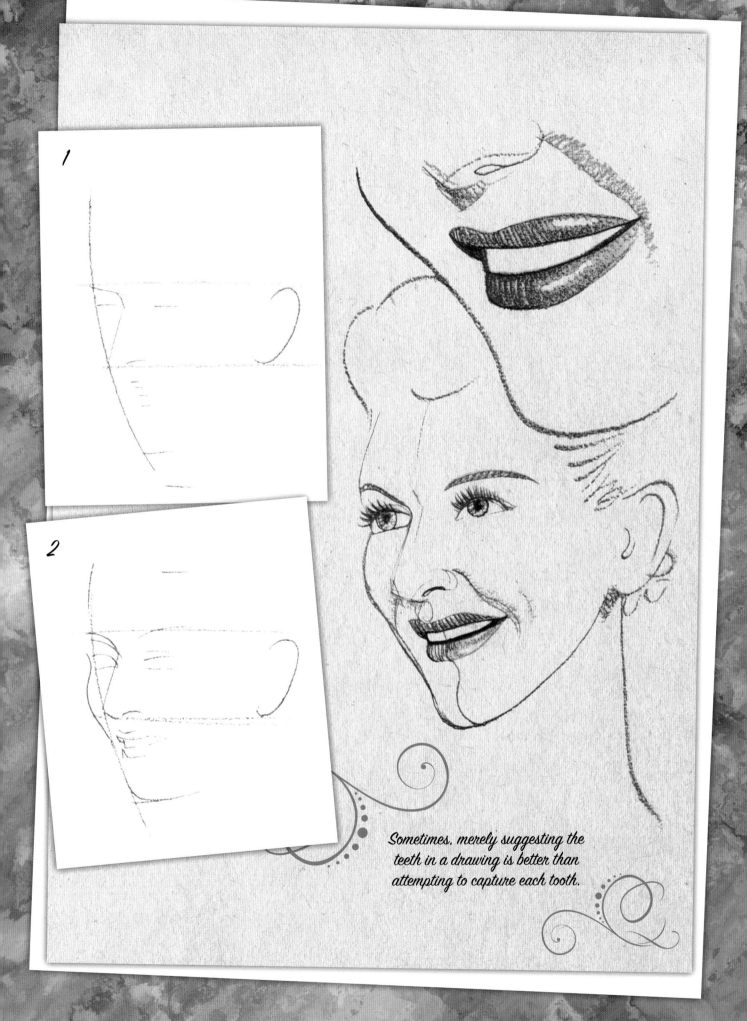

1

2

Sometimes, merely suggesting the
teeth in a drawing is better than
attempting to capture each tooth.

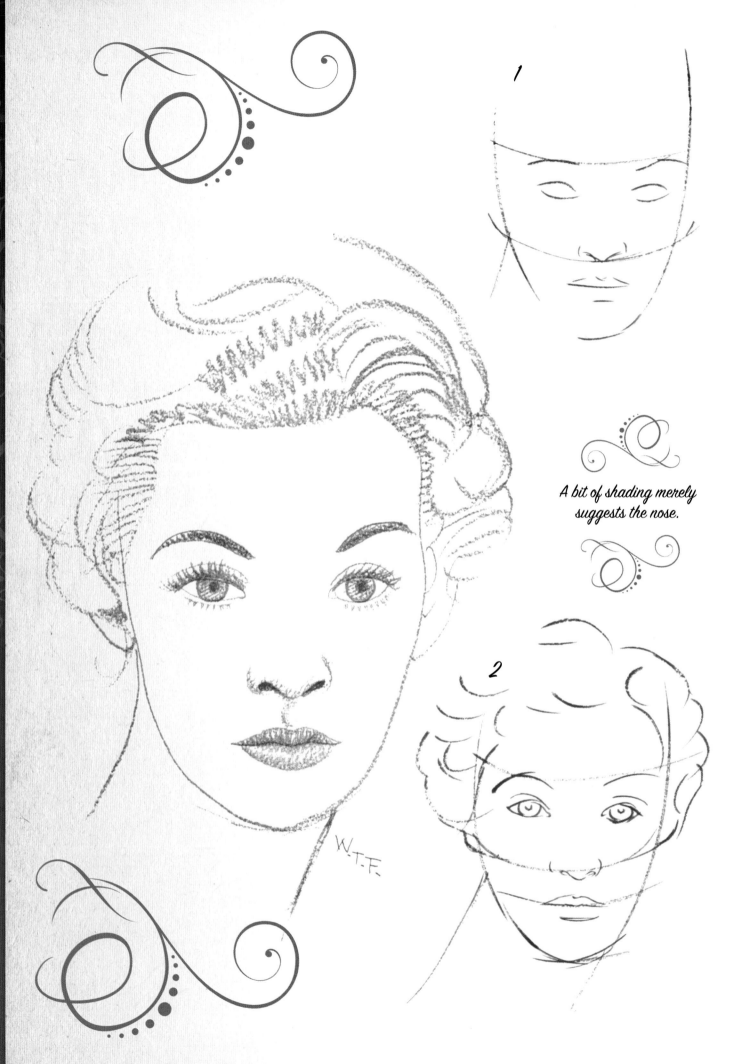

1

A bit of shading merely
suggests the nose.

2

W.T.F.

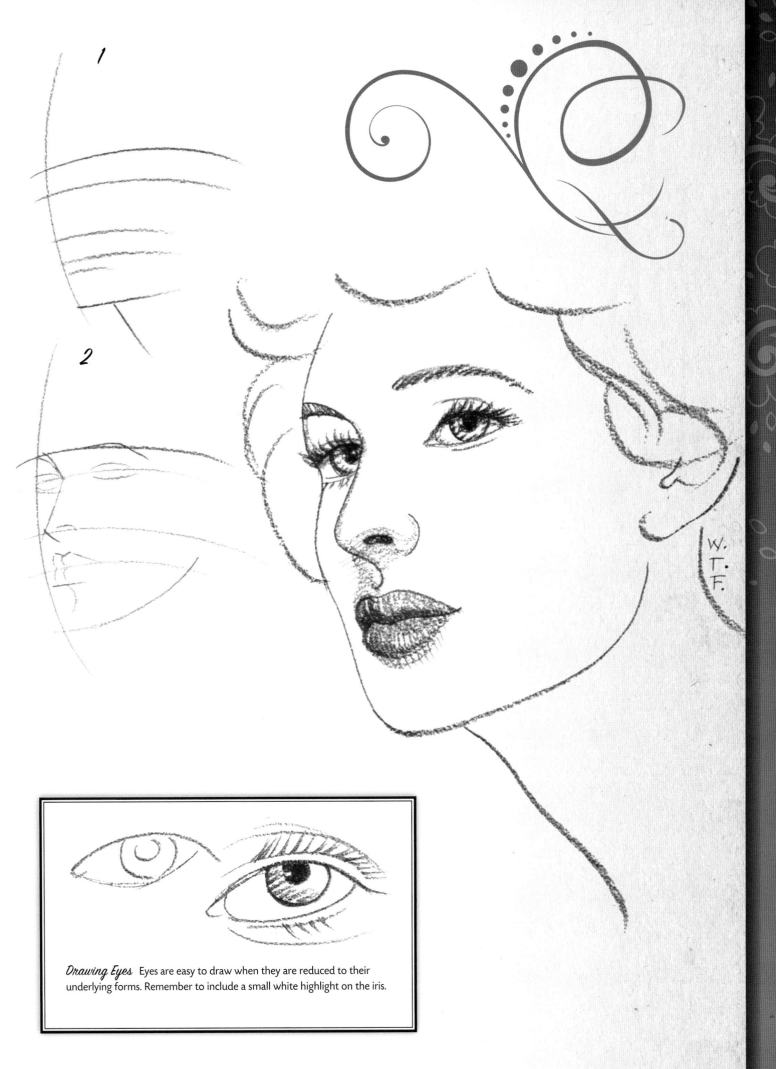

1

2

W.
T.
F.

Drawing Eyes Eyes are easy to draw when they are reduced to their underlying forms. Remember to include a small white highlight on the iris.

Once again, don't be afraid to reduce the head down to a few basic shapes. Doing so will help you improve your technique over time.

1

2

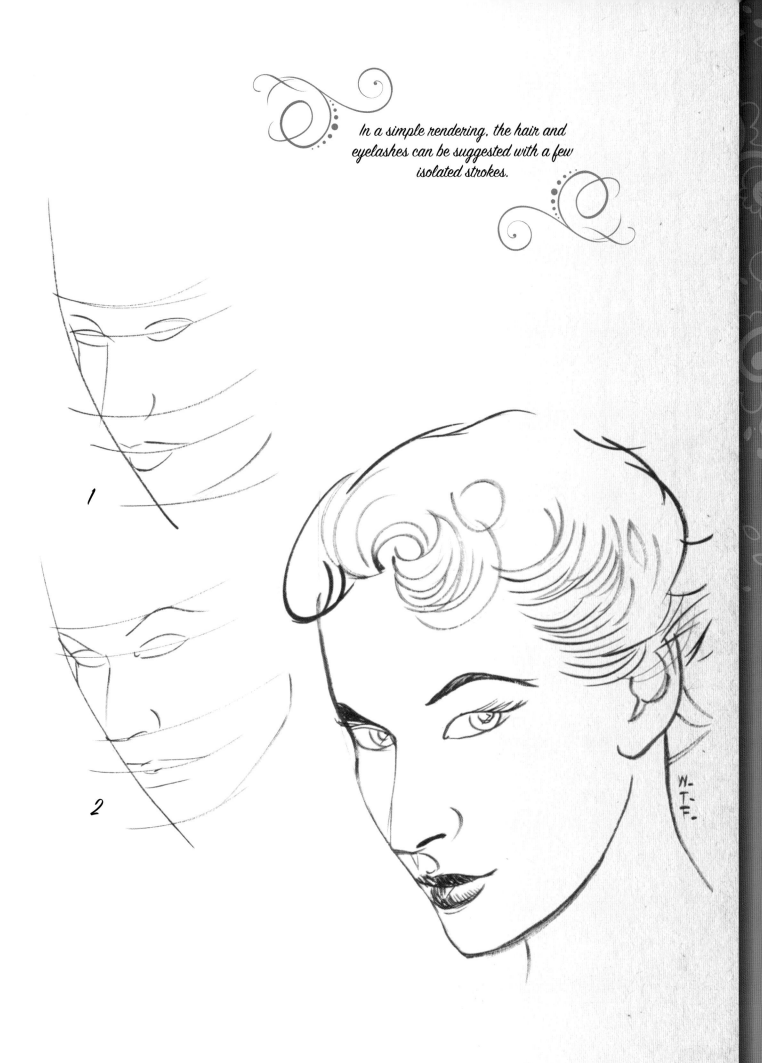

In a simple rendering, the hair and eyelashes can be suggested with a few isolated strokes.

1

2

47

S hading can be used in multiple ways to add dimension and drama to your drawings. In this case, rendering a part of this face in shadow adds an air of mystery and sophistication.

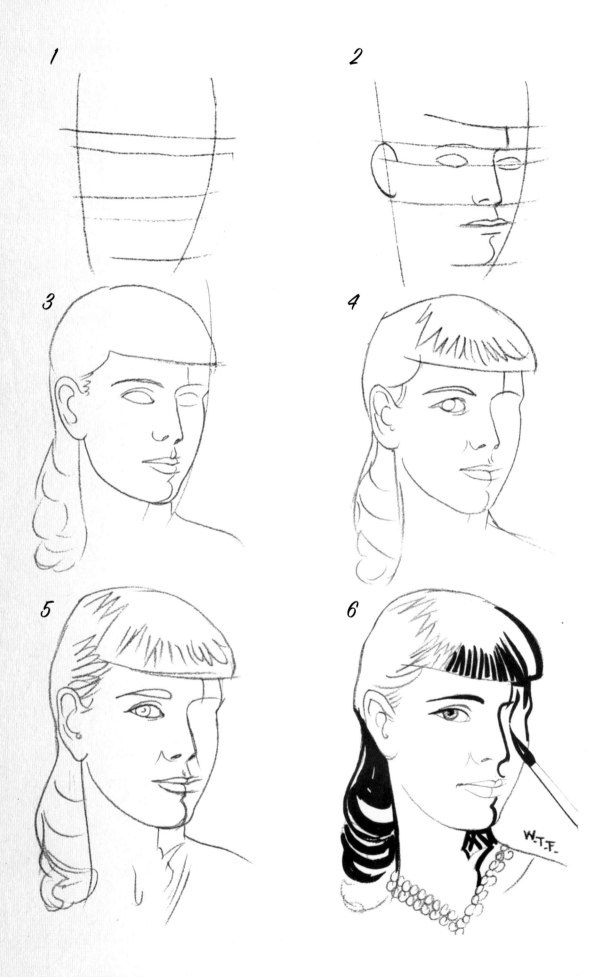

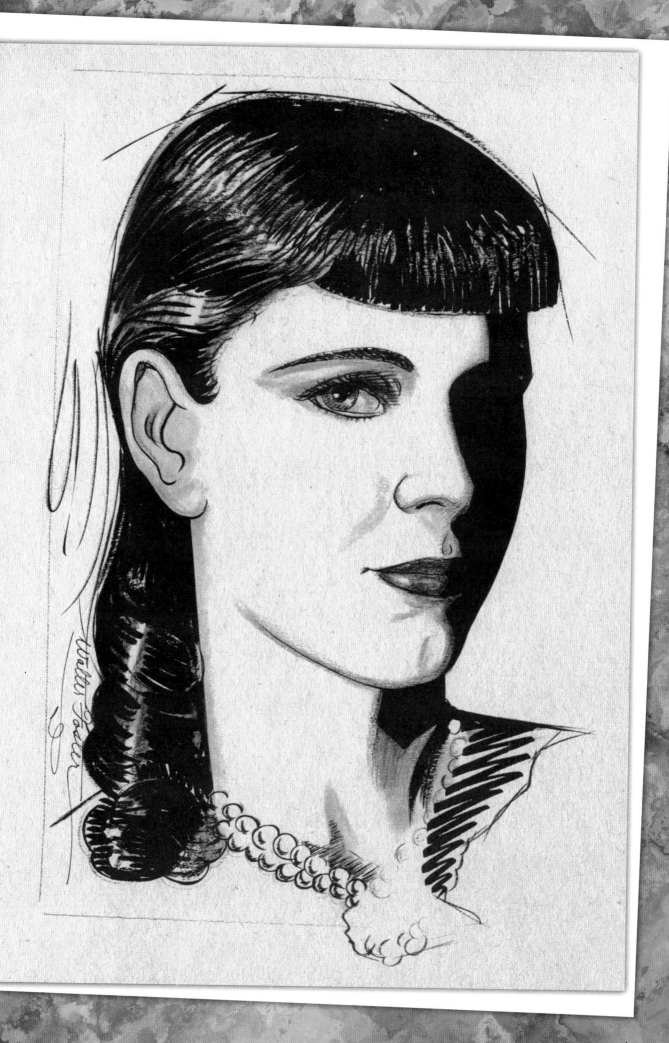

A combination of strokes were used to indicate this subject's thick, healthy head of hair and dramatic lipstick. Experimenting with a variety of pencil strokes can often yield unexpected, interesting, and welcome results.

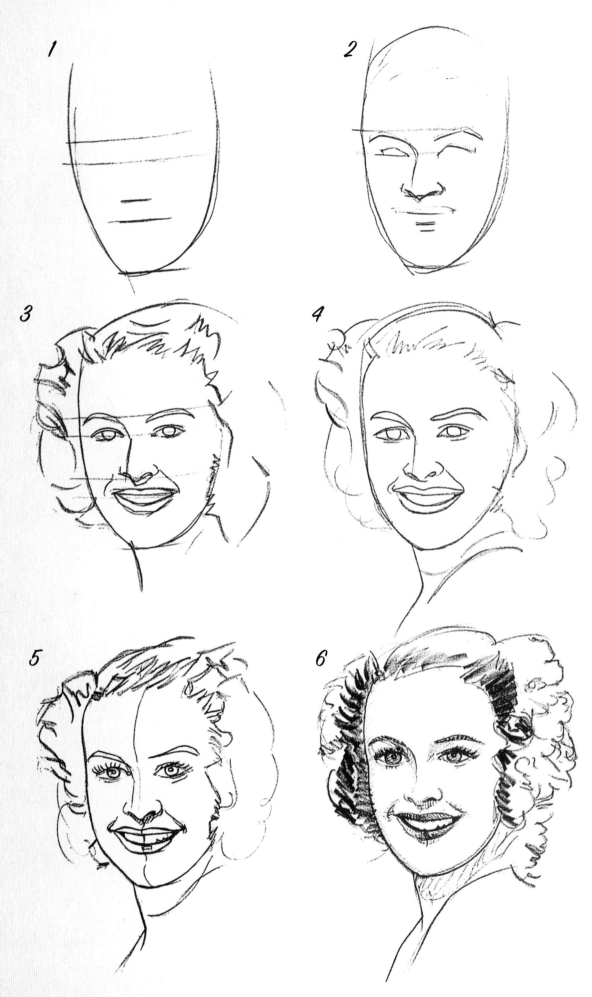

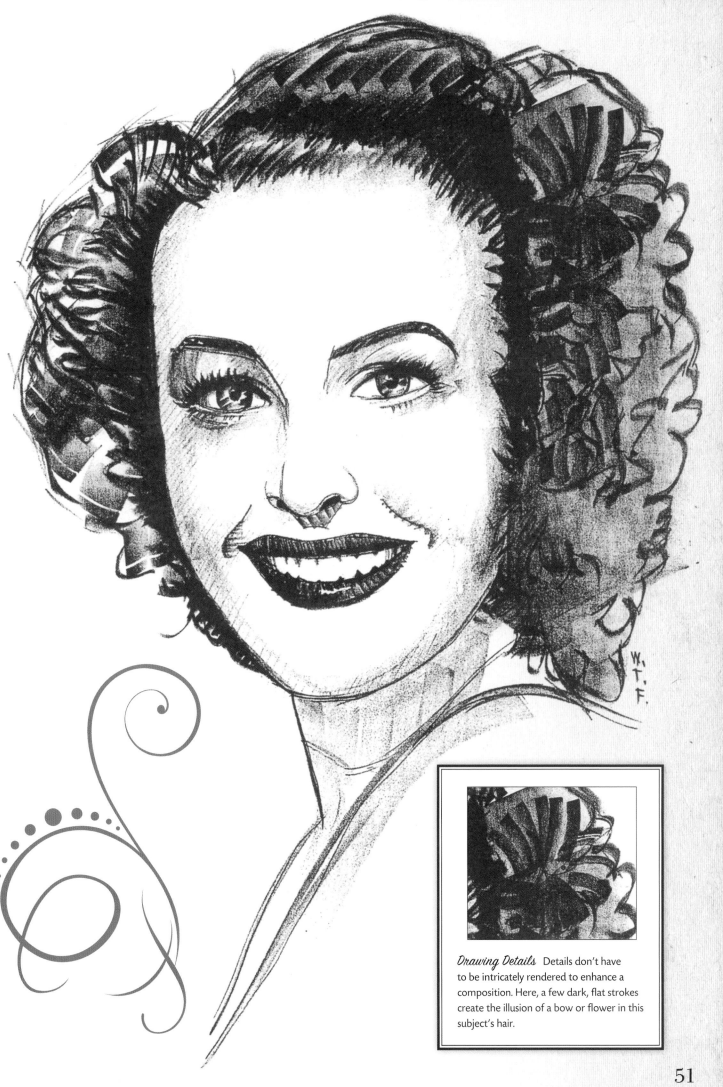

Drawing Details Details don't have to be intricately rendered to enhance a composition. Here, a few dark, flat strokes create the illusion of a bow or flower in this subject's hair.

This drawing is another example of using just a few long sweeping lines, a bit of shading, and some quick, uncomplicated strokes to indicate clothing. In this case, an elegant headscarf.

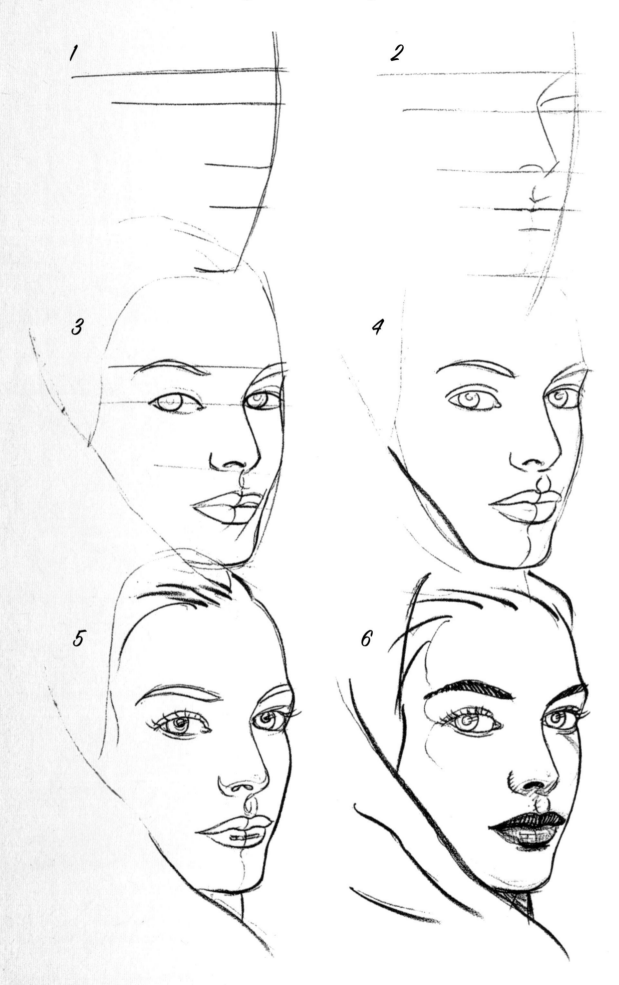

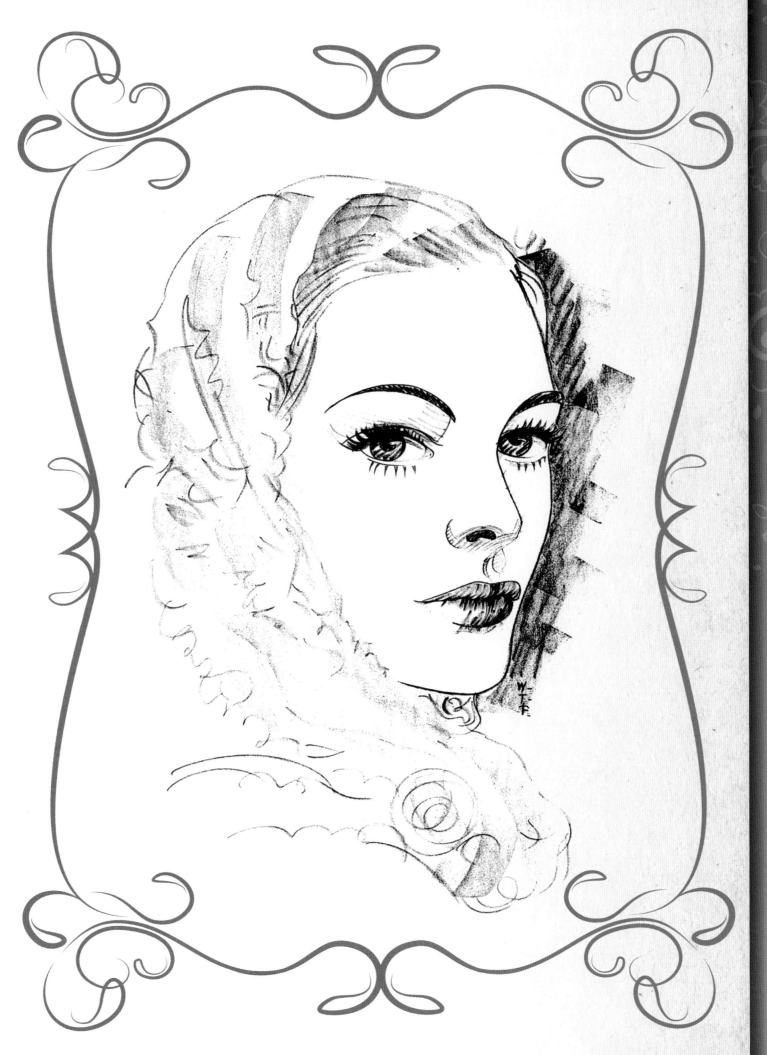

Browsing through books and magazines is a great way to find interesting drawing subjects. The more you practice and the more diverse your subjects are, the better your drawings will be. Young or old, male or female, all portraits start with the same basic steps.

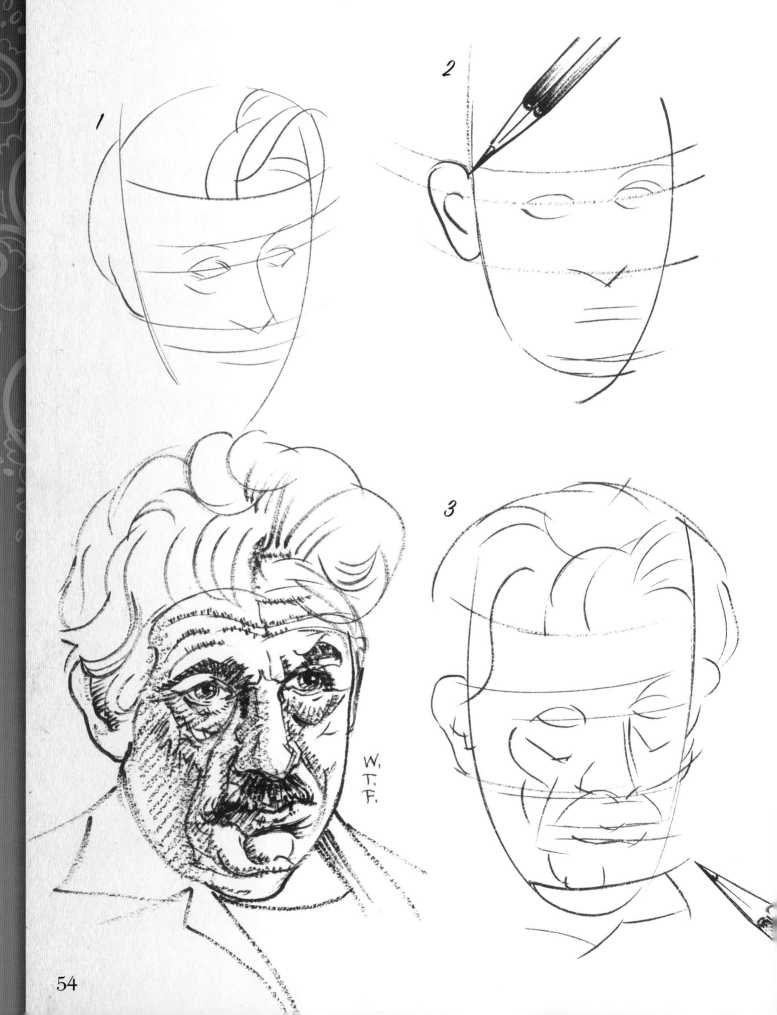

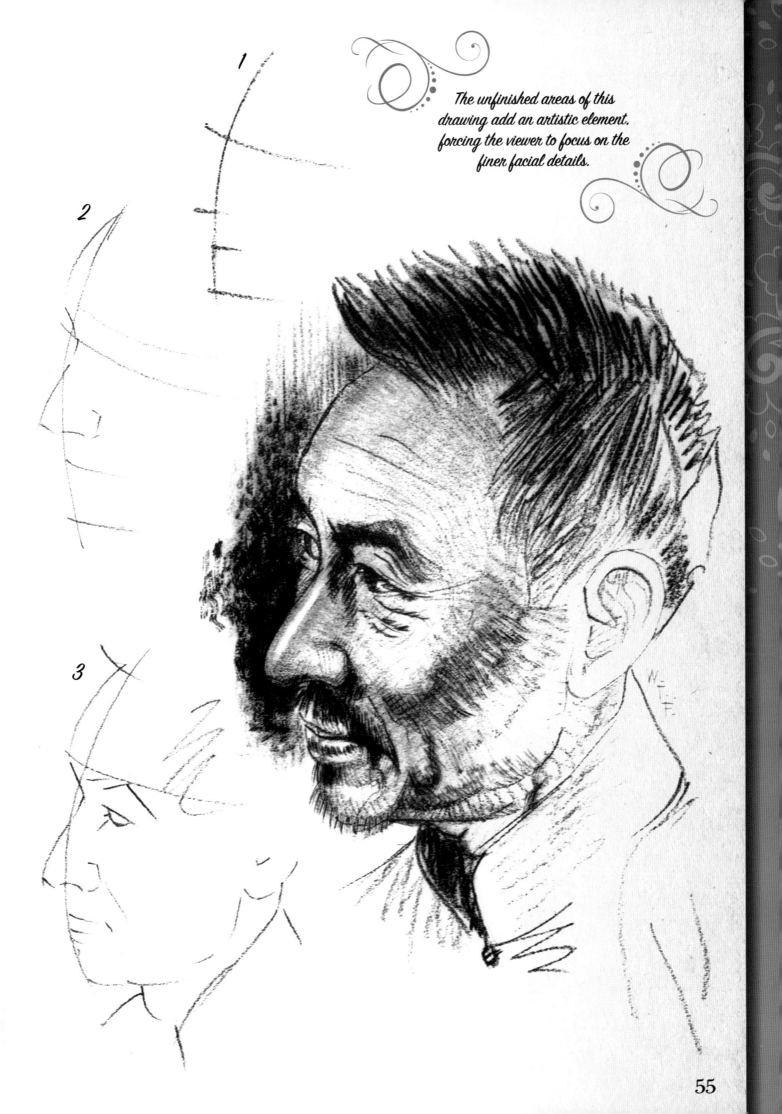

1

2

3

The unfinished areas of this drawing add an artistic element, forcing the viewer to focus on the finer facial details.

Clothing can be used to identify a subject's background and heritage. Feel free to experiment with various types of costume and dress, as embellishing your drawings in this way will make them uniquely yours.

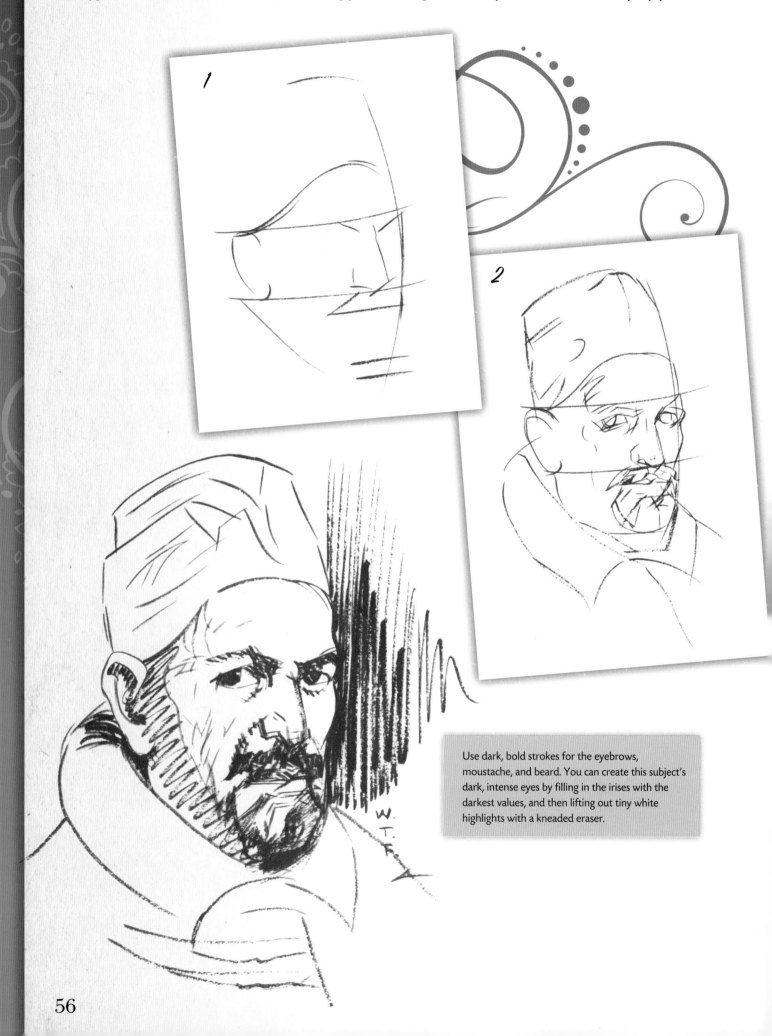

Use dark, bold strokes for the eyebrows, moustache, and beard. You can create this subject's dark, intense eyes by filling in the irises with the darkest values, and then lifting out tiny white highlights with a kneaded eraser.

This drawing was modeled after an Old Master's painting. Copying a Master's work is excellent practice, and it helps to improve your artistic skills.

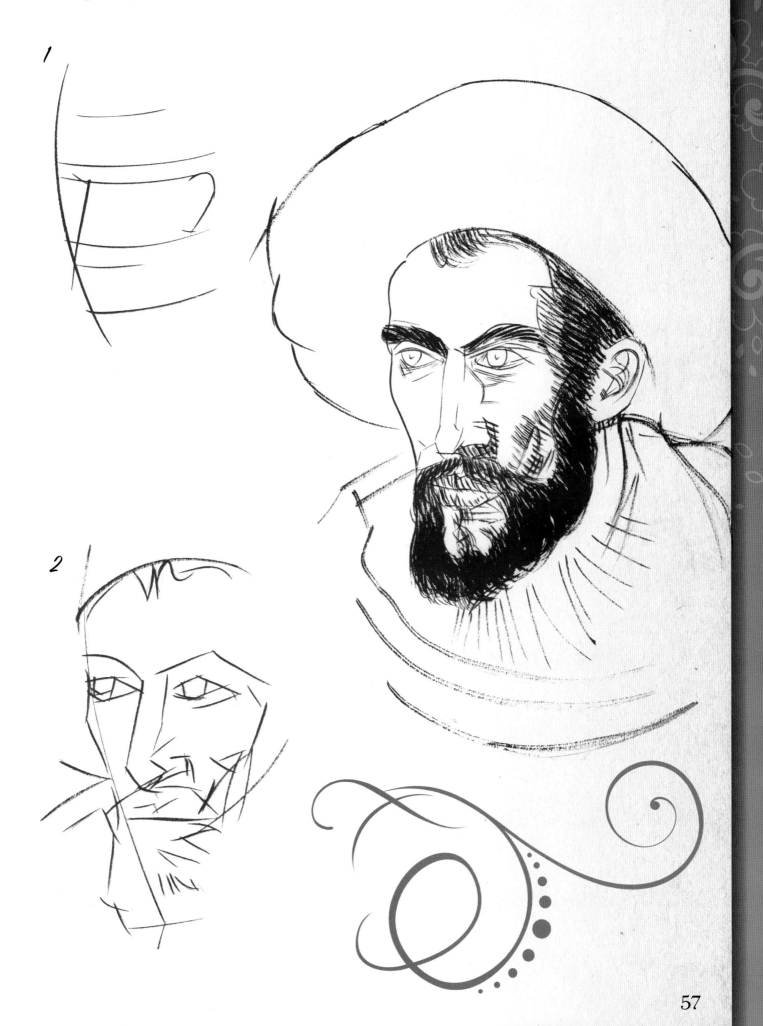

Examine the finished drawing on the opposite page. What does the subject's expression communicate? Is it reservation? Worry? Curiosity? Sadness? Capturing an accurate likeness involves considering mood and expression as much as it involves perfecting technique.

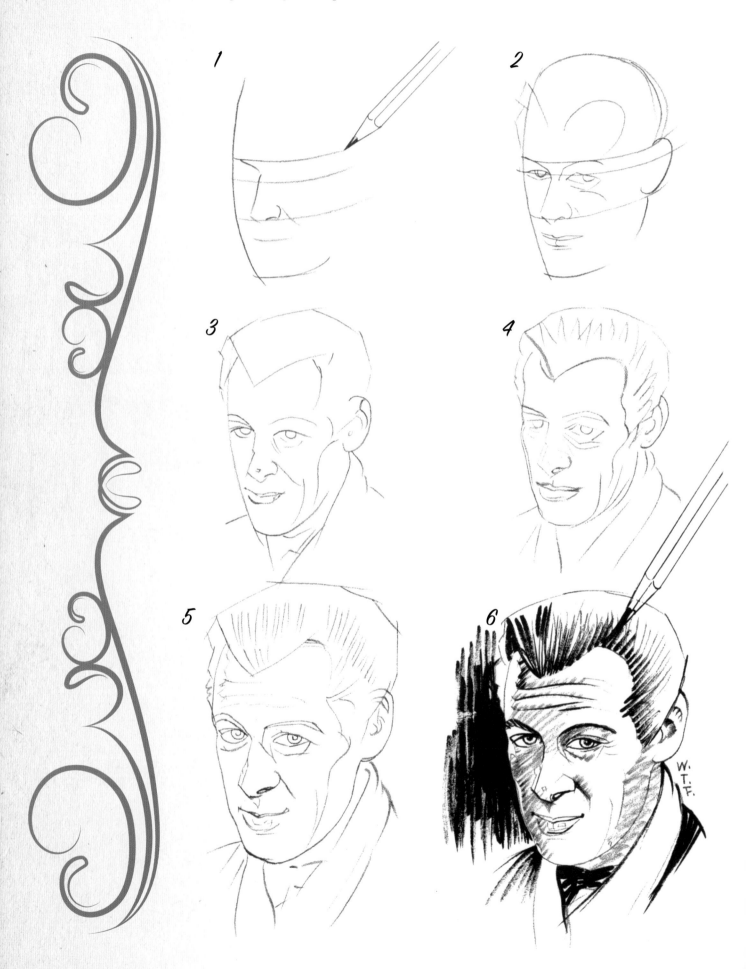

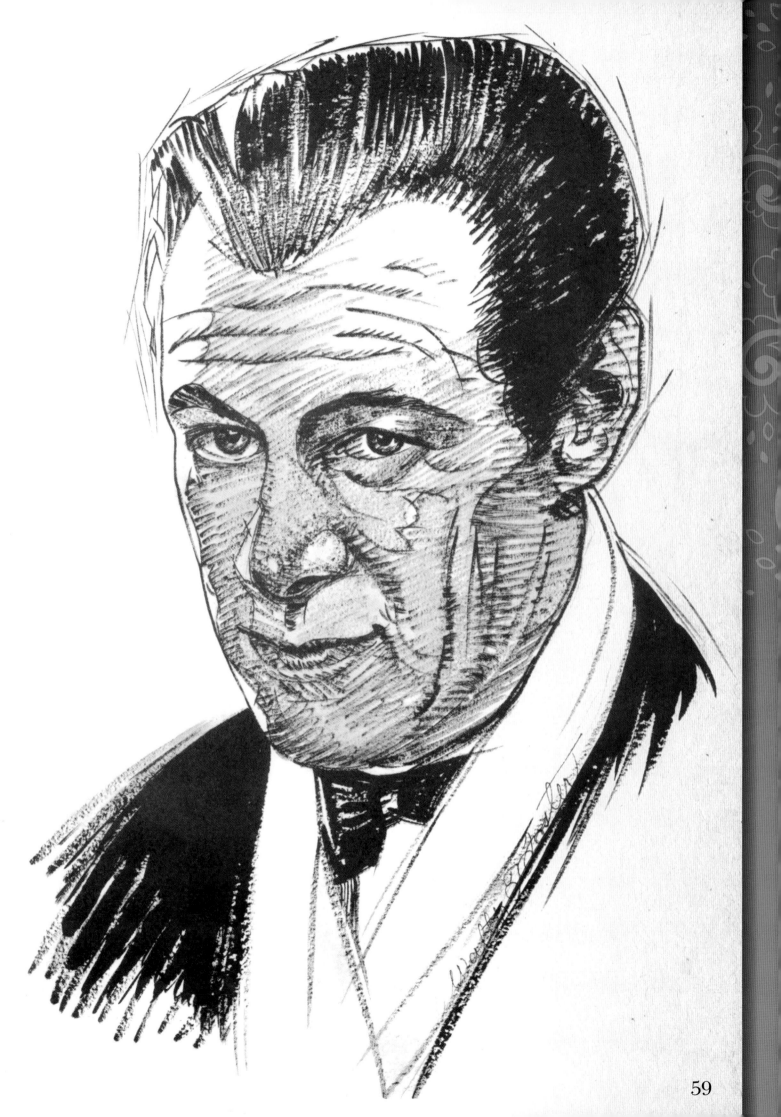

One of the most common mistakes when drawing the head is attempting to "fix" a problem by adding shading. But if the proportions are not right to begin with, shading will only add to the problem.

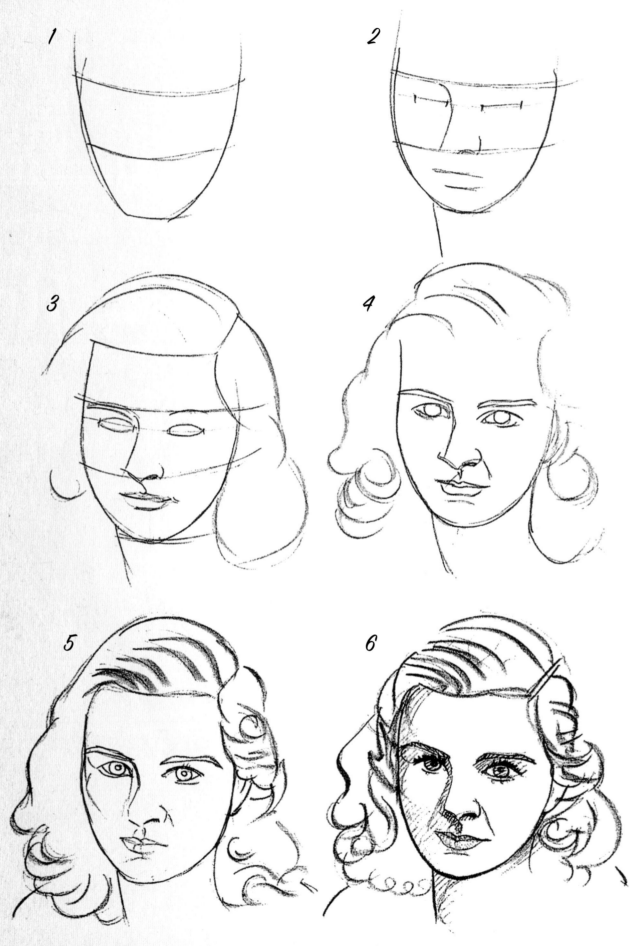

1

2

3

4

5

6

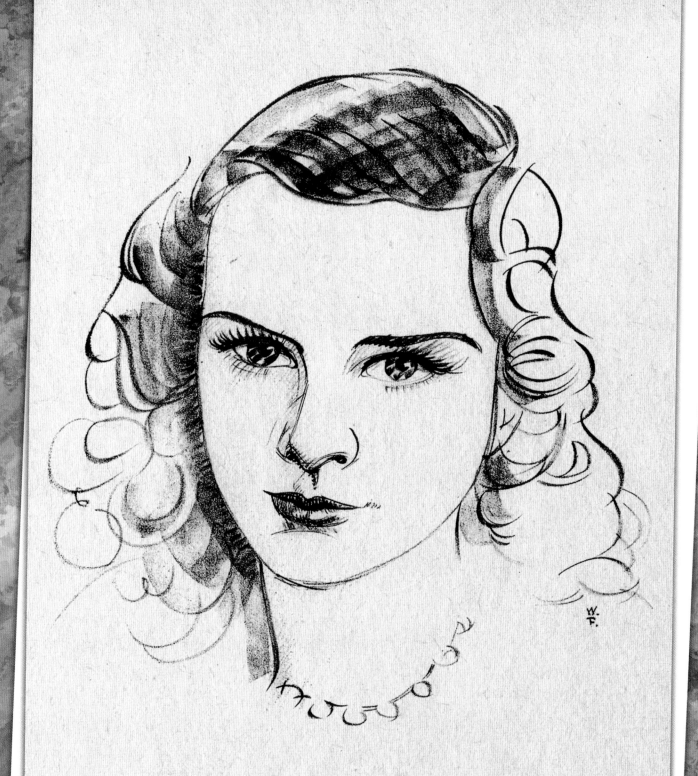

If you don't have a model to work from, try drawing a self-portrait. Many of the Masters practiced this way!

Note the distinct slant of this subject's nose and how the shading around it helps accentuate—not detract from—its shape and size. The various shading techniques used in this drawing significantly enhance its stylistic appeal.

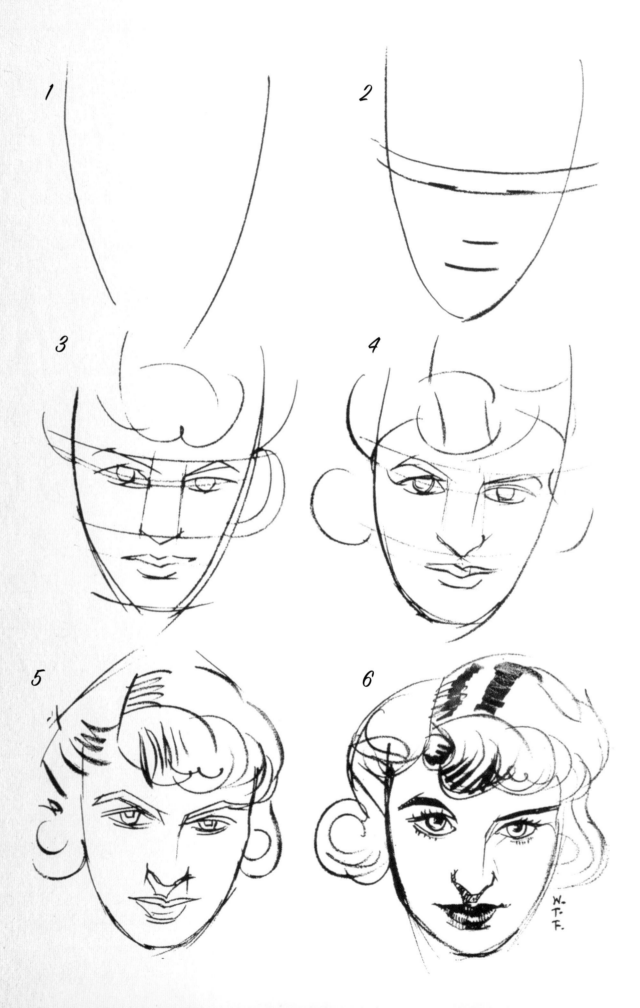

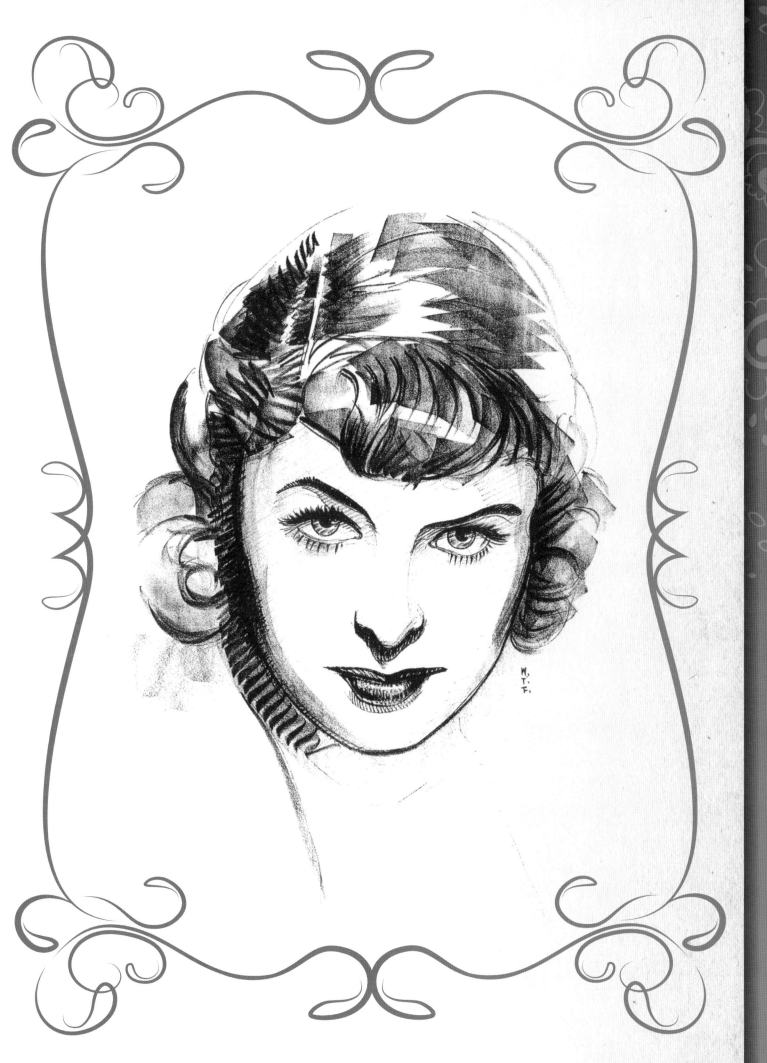

You may choose to draw on a toned surface, as shown in the final step on the opposite page. Because this provides a middle value from the start, you have to add only the lights and darks. In this example, white accents have been added using strokes of white paint.

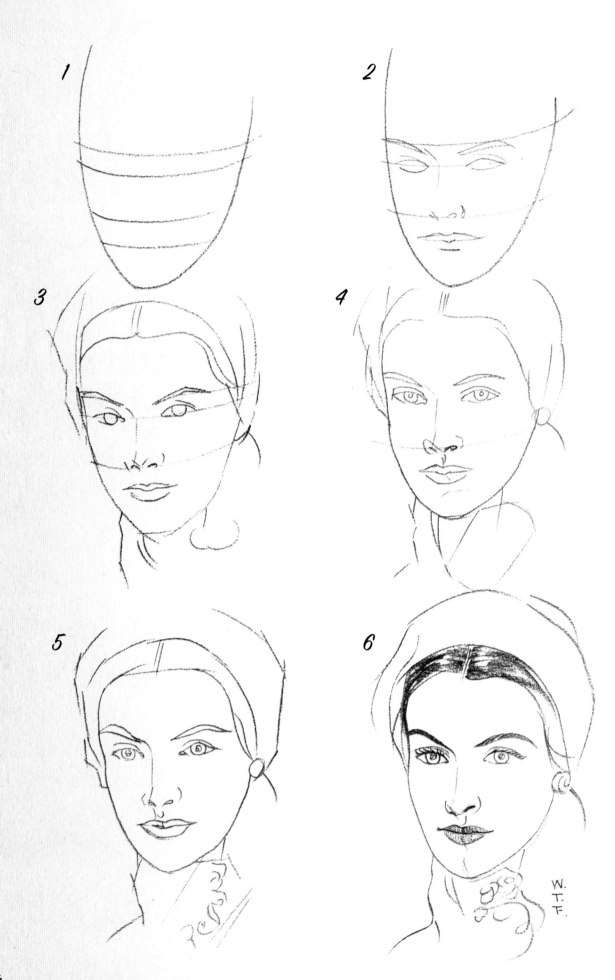

1

2

3

4

5

6

W.
T.
F.

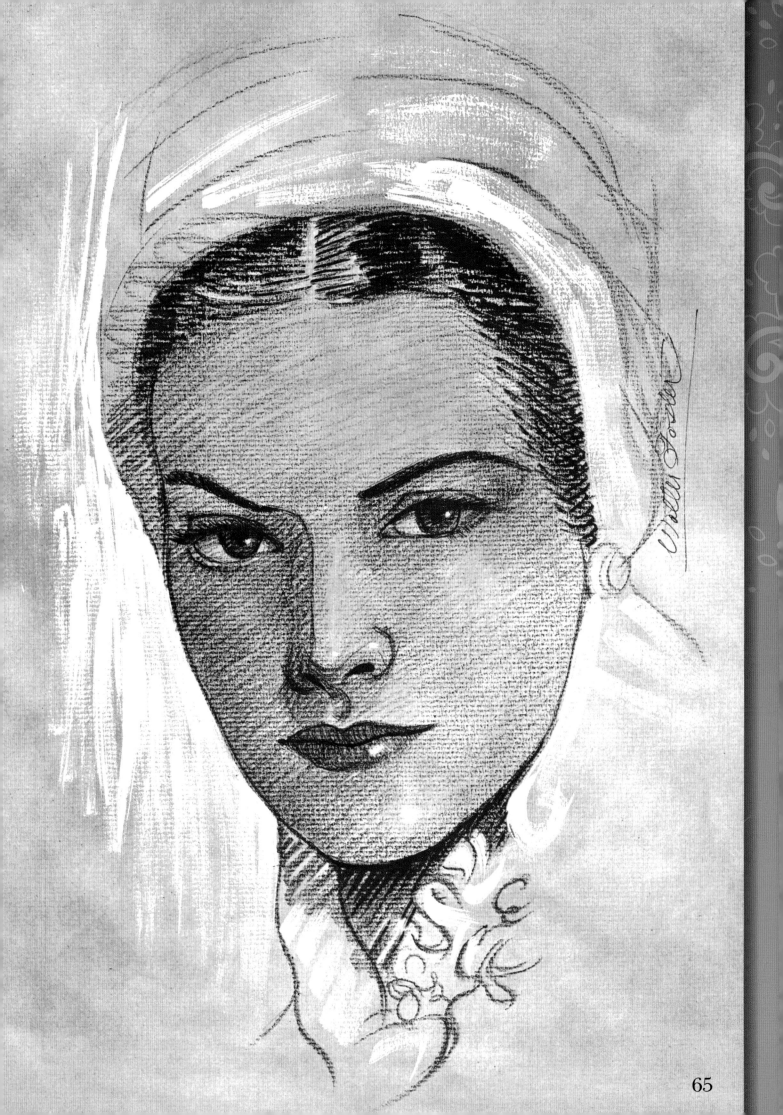

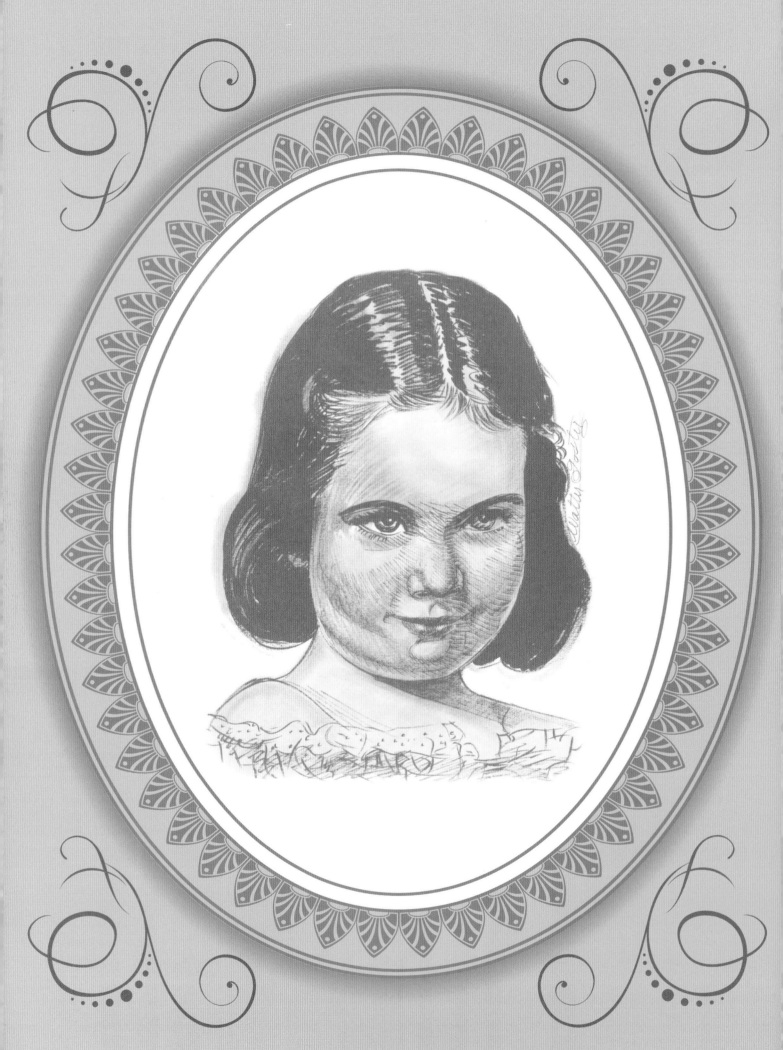

Chapter 3: Children & Young Adults

Capturing the essence of a child's innocence and wonder in a drawing is one of the most rewarding endeavors an artist can undertake. But it can be challenging, as well. Take time to make sure the proportions of the face correlate with the age of your subject, as a child's face changes from one developmental stage to another. After completing the exercises in this chapter you will be more familiar with the different phases of growth and will be ready to draw children from life. Try experimenting with different expressions and light sources, but above all, always remember to capture the sparkle in their eyes!

Profile, Three-Quarter & Side Views

When drawing a child's face, follow the same basic steps as you would for drawing an adult's face. Sketch the guidelines first, block in the basic facial features, and then work on refining the shapes and adding the details.

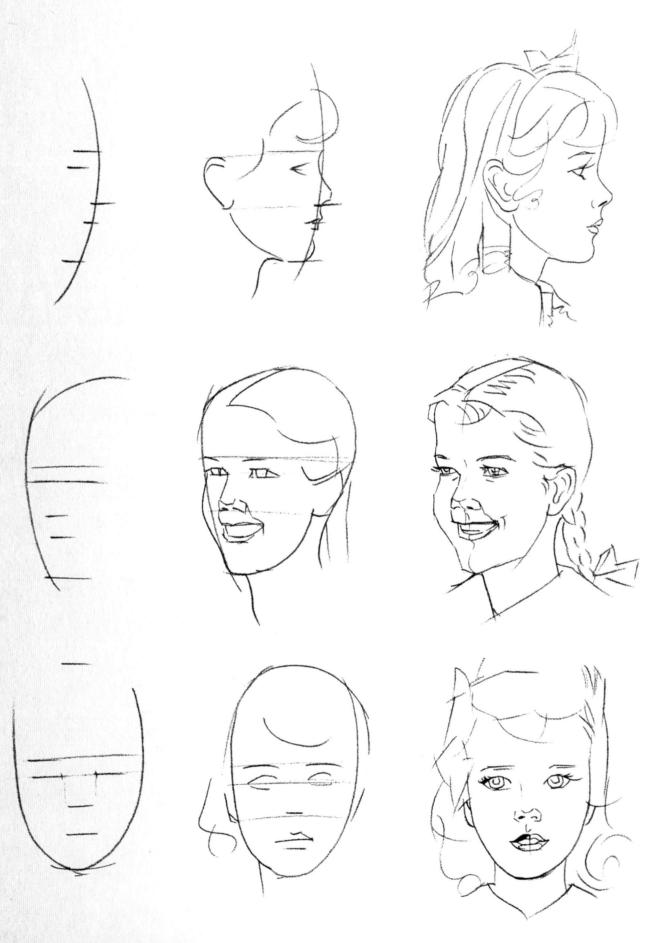

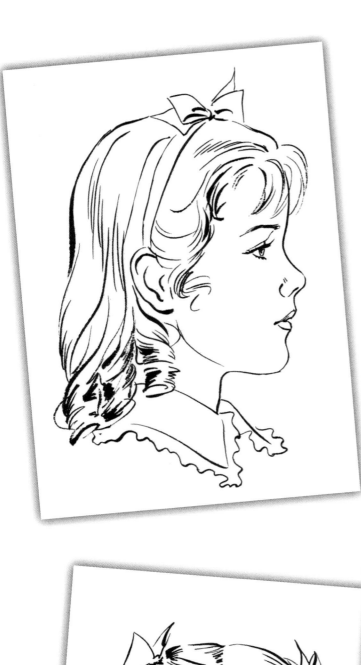

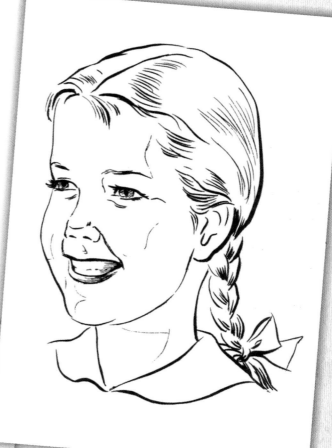

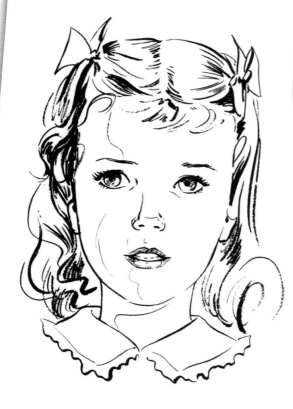

Finishing Touches Adding minor details, such as dimples, freckles, or bows, adds an authentic and personal touch to a child's portrait.

Your artistic style should always reflect the nature of your subject. To achieve a youthful look, use clean, polished lines and minimal shading. Consider how some details, such as elongated eyelashes in the drawings on these pages, help enhance a youthful, innocent appearance.

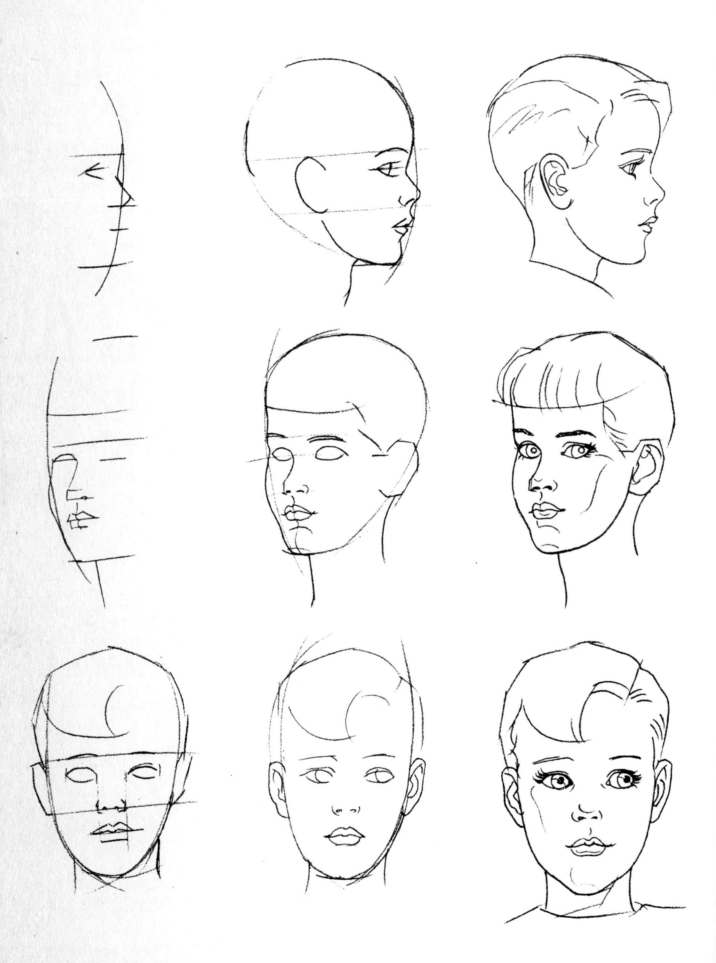

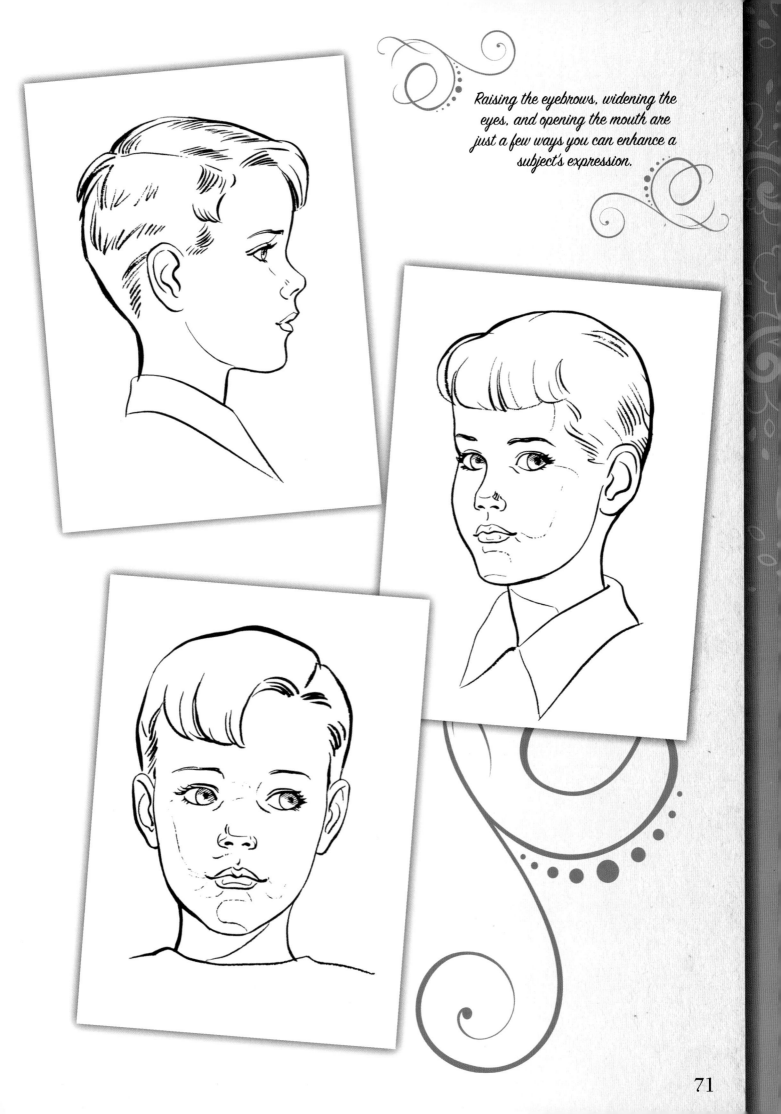

Raising the eyebrows, widening the eyes, and opening the mouth are just a few ways you can enhance a subject's expression.

Teenage Boy

When drawing a portrait, don't worry about trying to immediately "capture" a subject's expression. Instead, let the mood evolve naturally. Notice how this subject's expression is not fully realized until shading is added to the final drawing. The dark shading in and around the subject's eyes seems to suggest a subtle intensity and pensive mind deep in thought.

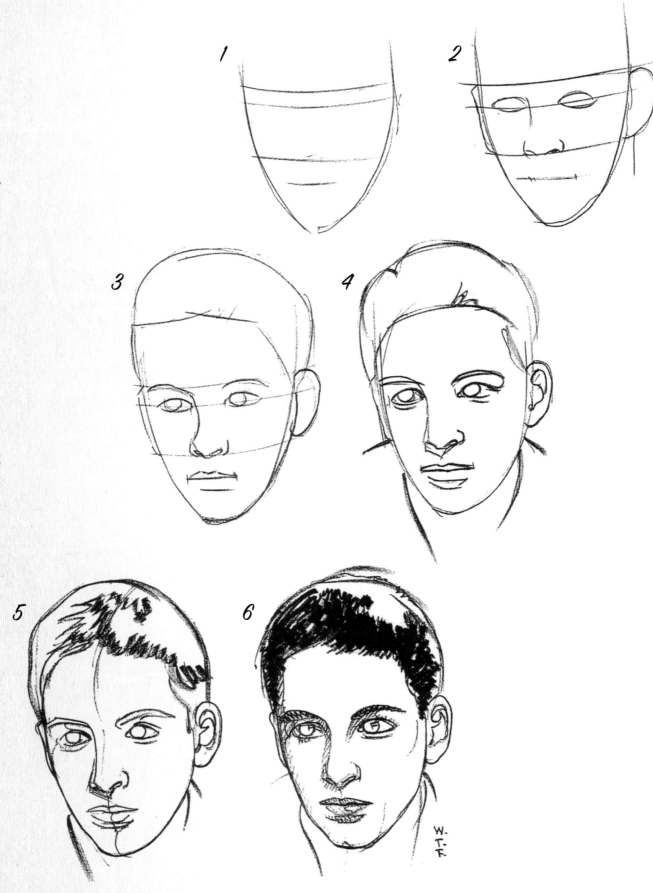

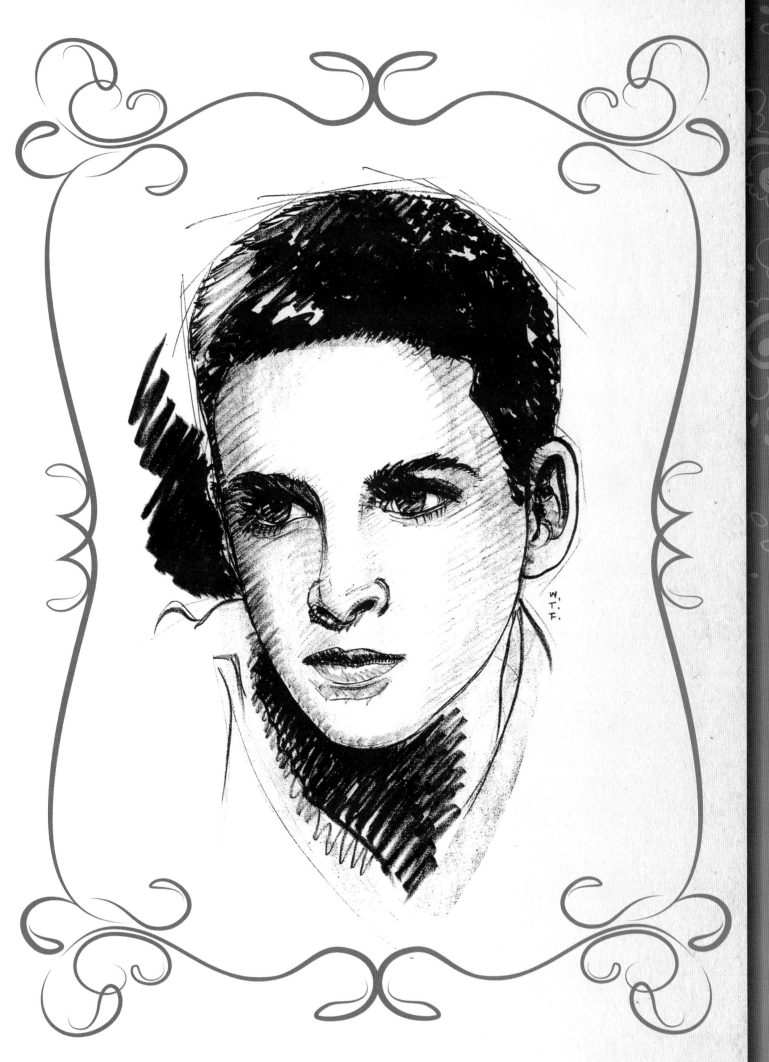

Teenage Girl

Always consider how the direction of light might affect your composition. Notice how the shading in the drawings on this and the opposite page clearly indicate where the light is coming from. Lighter shading or lifting out pencil marks with a kneaded eraser can help you create this effect.

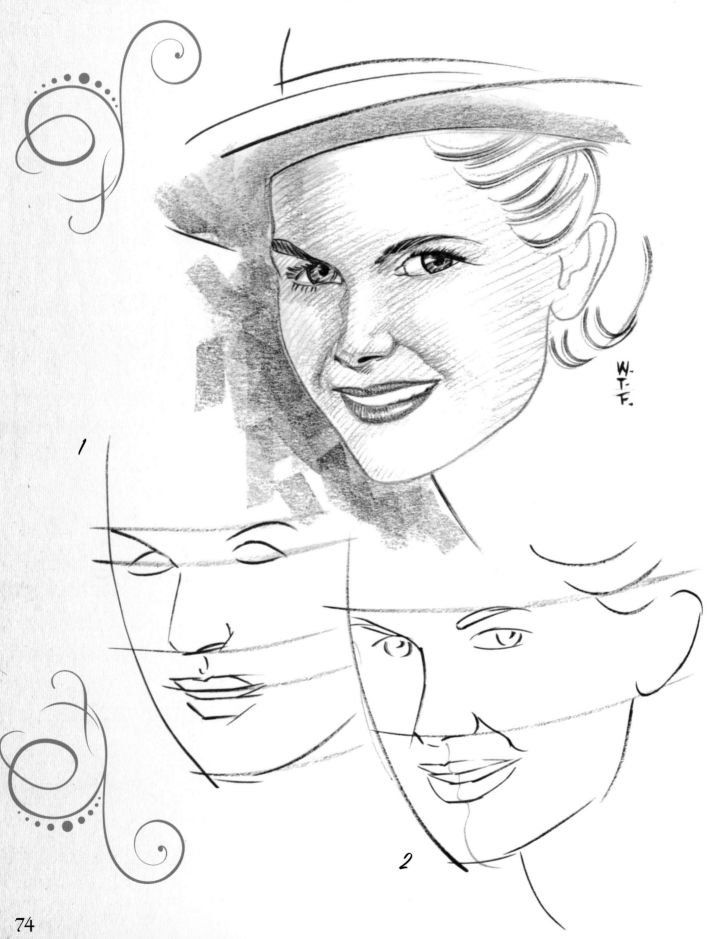

Young Boy

S tart with basic guidelines and build your subject's likeness from there. Dark vertical strokes in the background help define the outline of this subject's face.

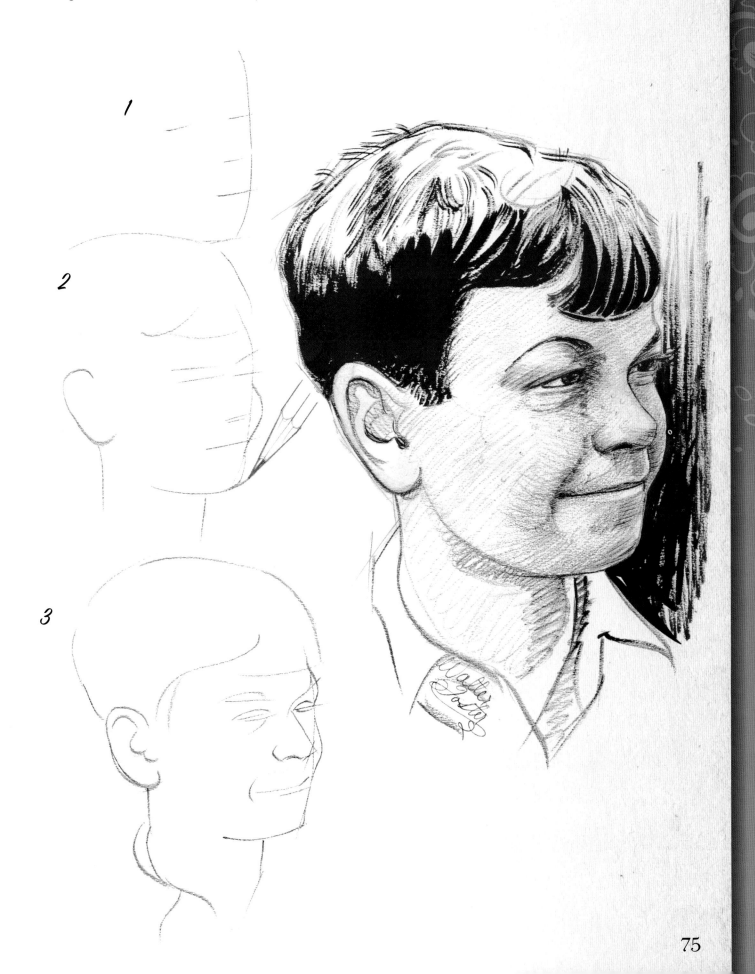

Young Girl

If you are still unsure about your drawing skills, place a sheet of tracing paper over the first step below and trace the guidelines. Then place the guidelines from step 1 over step 2 and continue to block in the features. Follow this pattern for steps 3 and 4; then remove the sheet and finish refining the features on your own. This exercise will help you get a better sense of how to sketch one step at a time to create a final drawing.

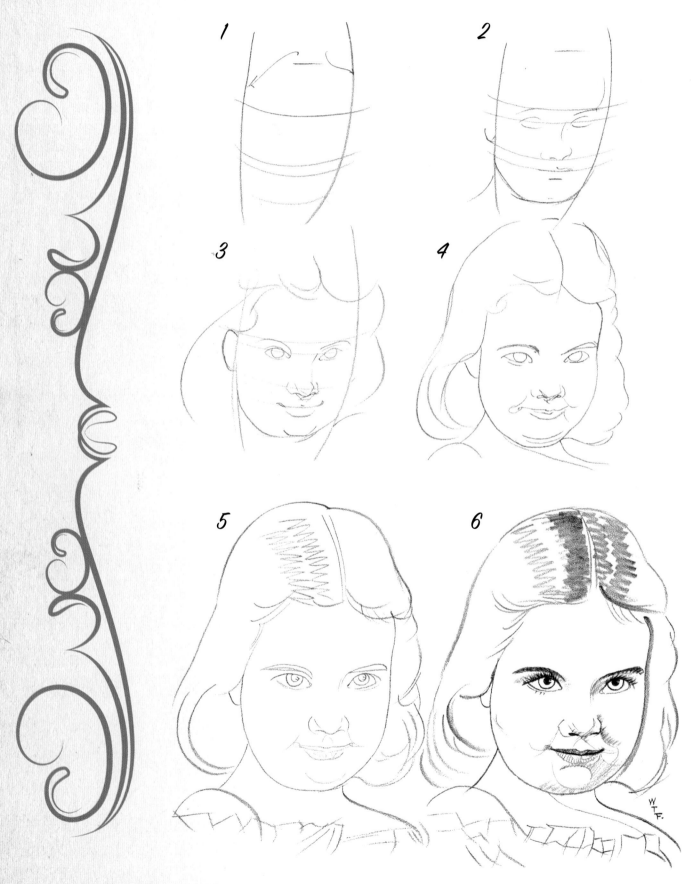

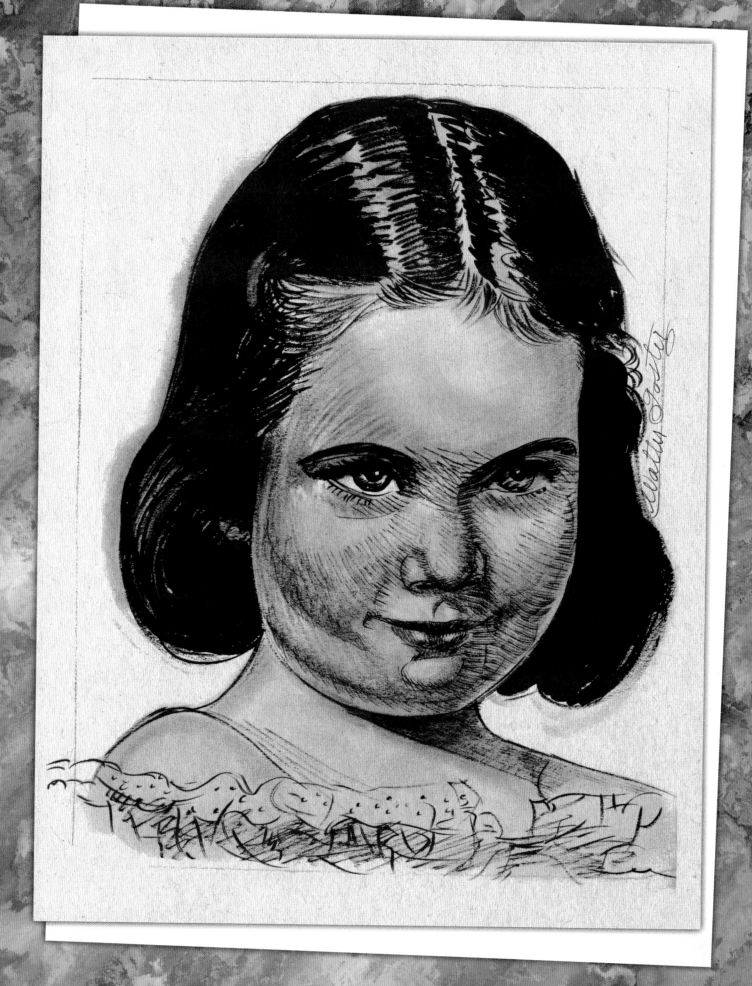

Foreshortening

In the poses on these two pages, the chin is positioned closer to the chest, but to different degrees. In both cases, the length of the face should be shortened in proportion to the angle of the head. This is an example of foreshortening.

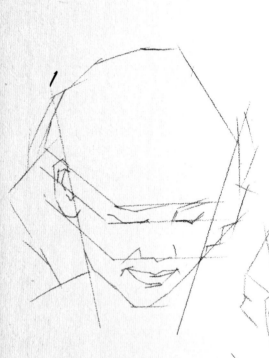

Sketch your guidelines so that they reflect the subject's foreshortened face (step 1). Continue to develop the features (step 2) and then suggest the hair and clothing (step 3). When you start shading, make sure to work in highlights around the hair to indicate its natural sheen (step 4).

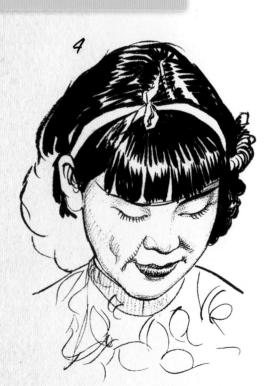

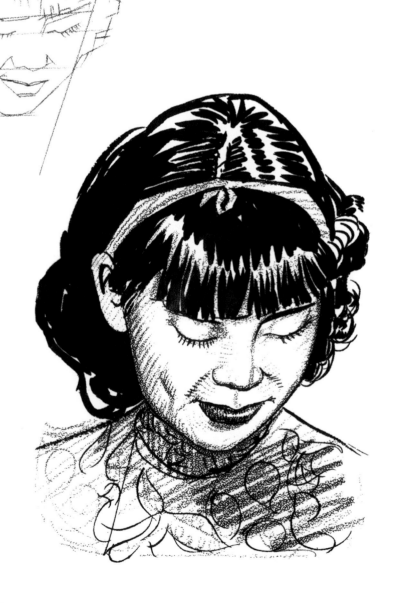

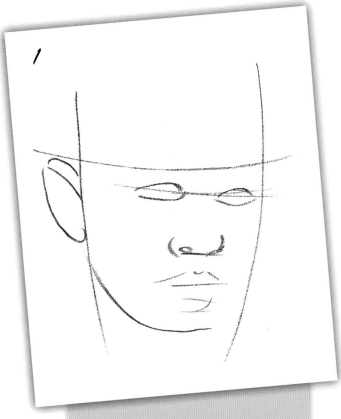

1

Use charcoal or a soft-lead pencil to shade over the face with even, parallel strokes. Leave areas of white for highlights, especially on the tip of the nose and the center of the lower lip.

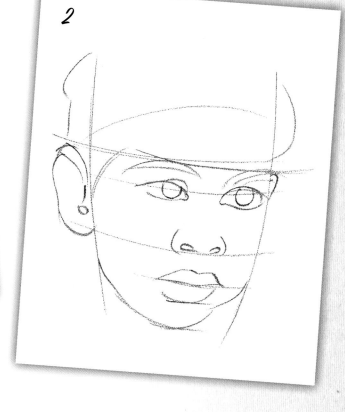

2

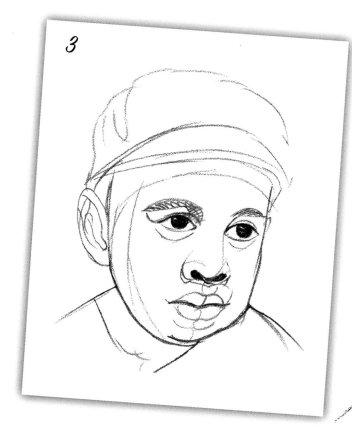

3

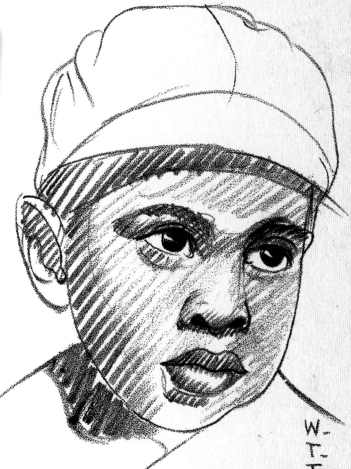

W-T-E

Expressions

Children have a wide-range of expressions that coincide with their many moods. Because it isn't realistic to depict every child as happy and smiling, experiment with capturing expressions that communicate other states of mind and mood, including sadness, anger, surprise, and excitement, among others.

1　　　*2*　　　*3*

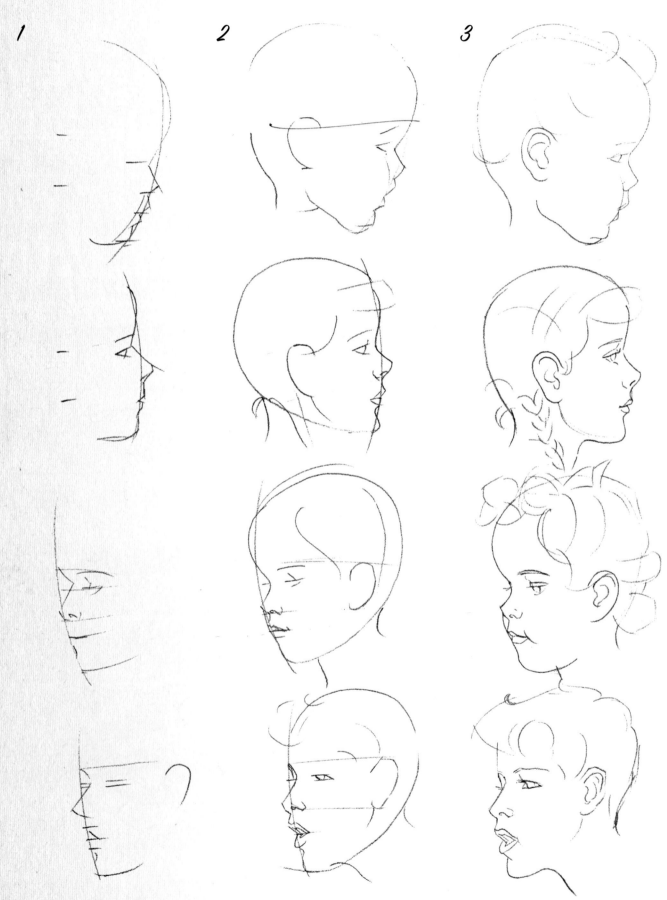

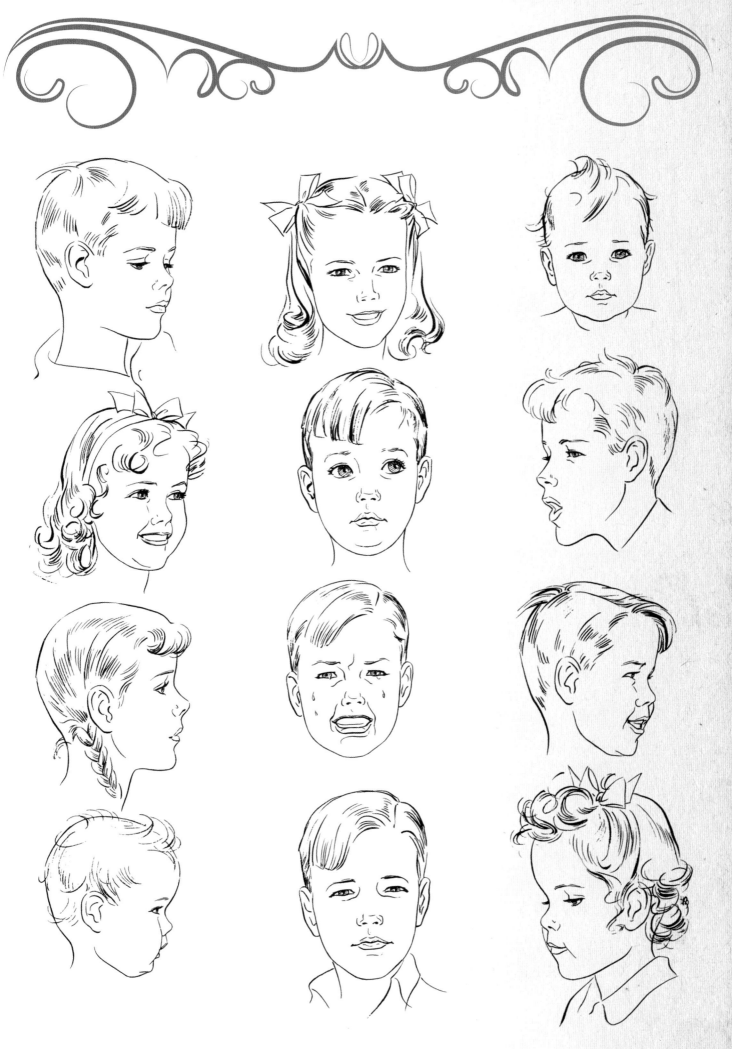

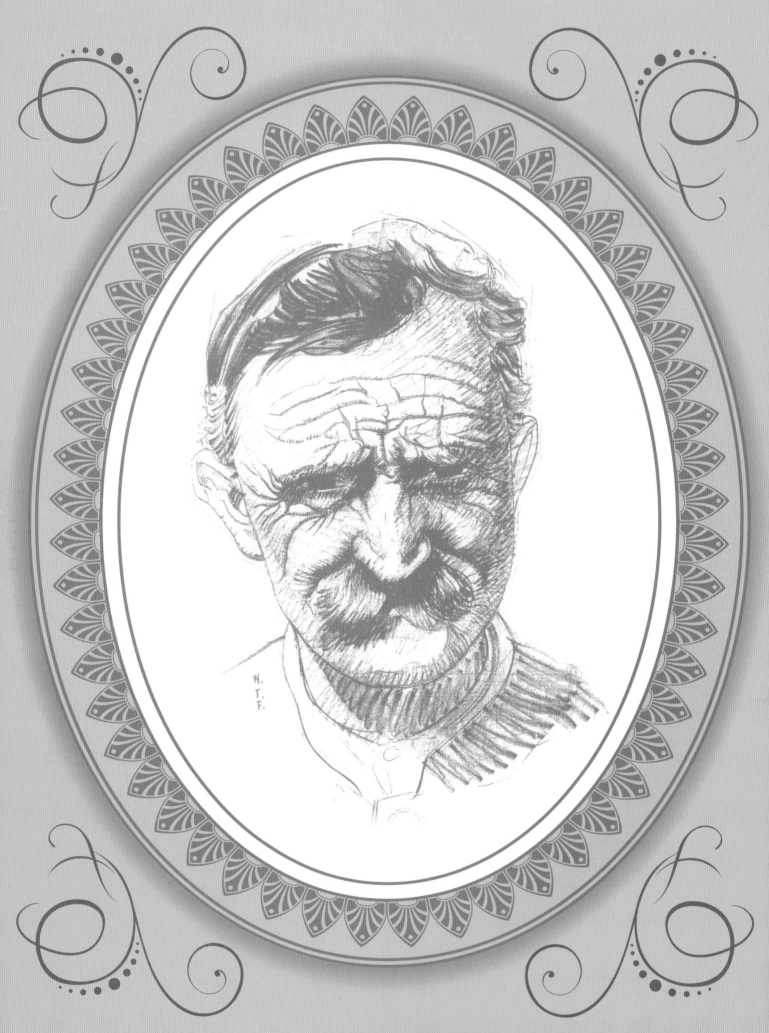

Chapter 4: Mature Faces

The aged and weathered faces of the elderly demand more line work and detail in their depictions, but they also convey a greater sense of character and mood. These portraits should tell their stories—who they are and where they've been. Has a subject's life been full of joy and reward, or sacrifice and turmoil? The way you sketch lines around the eyes and shade the contours and crevices of an individual's face will speak volumes about your subject's life experiences. Get to know your subject's character and draw an expression that is true to his or her nature. You will find that some of your favorite drawing subjects will be those who seem to have a compelling history hidden behind thoughtful eyes.

Women

These drawings capture the mood and character of each subject. The elderly woman on this page, for example, appears stern and serious; the woman on the opposite page, however, evokes a kind and gentle spirit. Feel free to indicate pronounced creases around the eyes and in other areas that will add to the character of your subject.

Using the usual proportion guidelines, block in the face and hat (step 1). Then add broad shapes to indicate the wrinkles and mature skin (step 2). Finish by refining the details and shading.

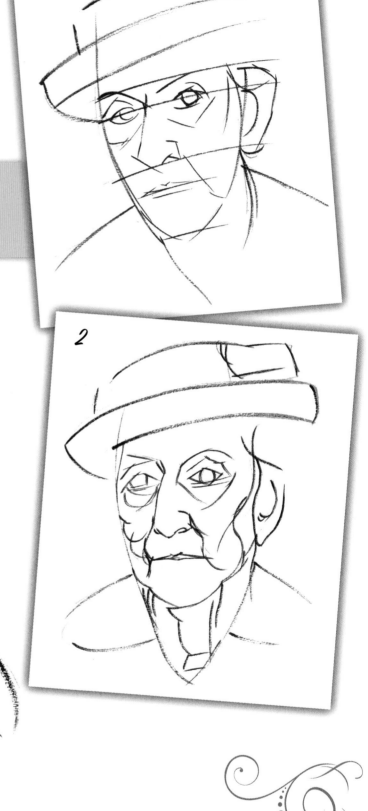

Using bold shading techniques helps create the appearance of weathered skin.

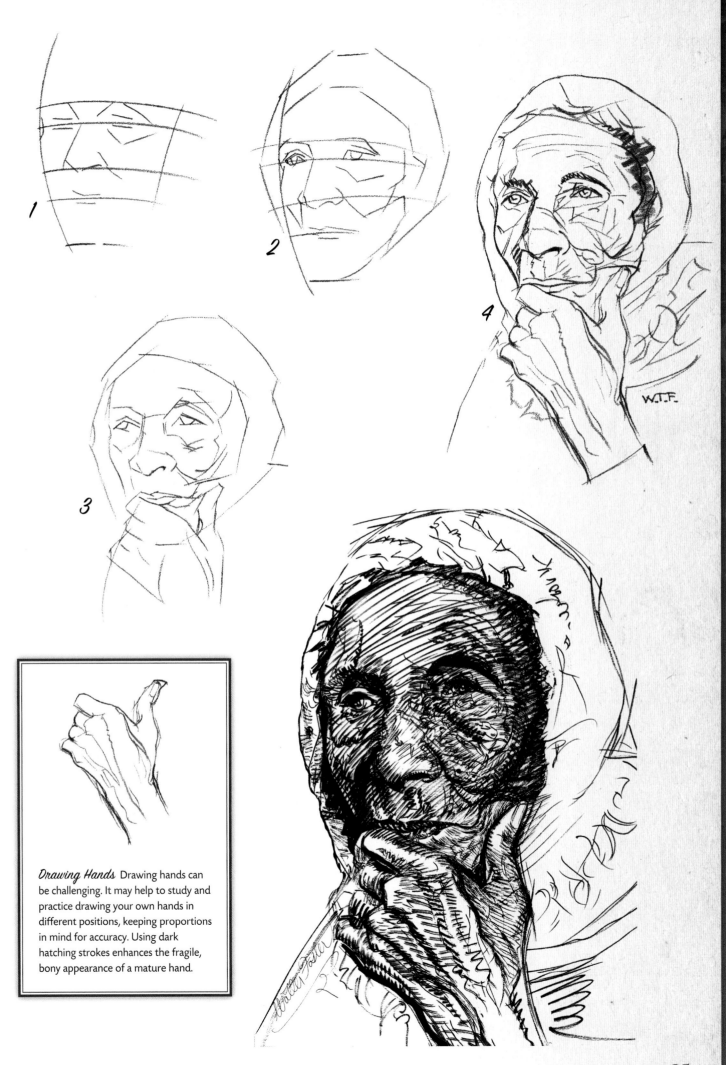

1

2

3

4

W.T.F.

Drawing Hands Drawing hands can be challenging. It may help to study and practice drawing your own hands in different positions, keeping proportions in mind for accuracy. Using dark hatching strokes enhances the fragile, bony appearance of a mature hand.

This subject has very distinct facial features. As you follow the steps, notice the manner in which each of the features is developed and how shading is used to add depth and interest.

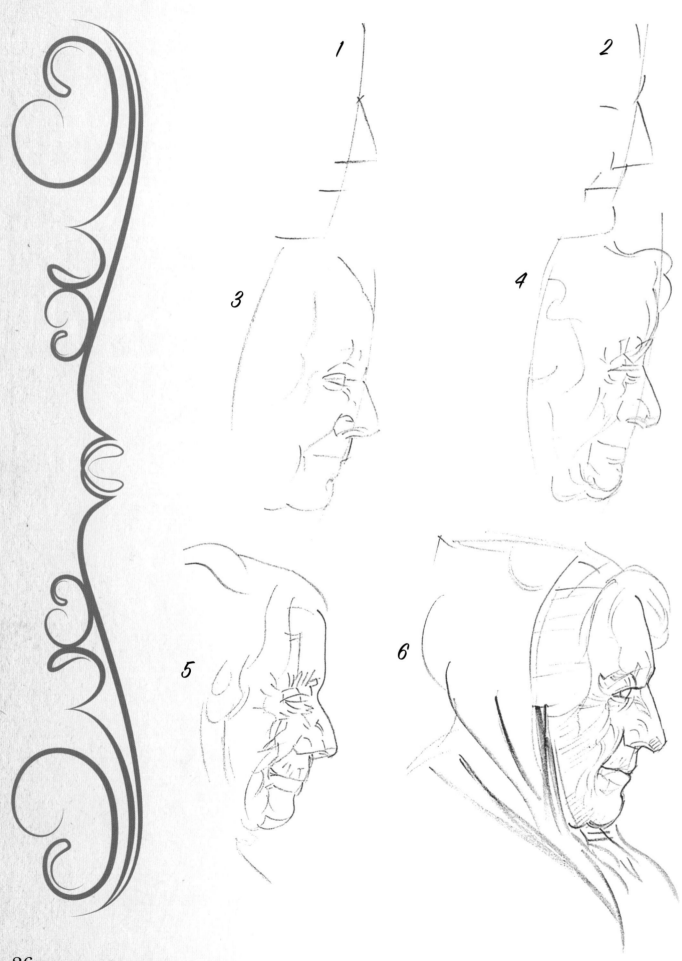

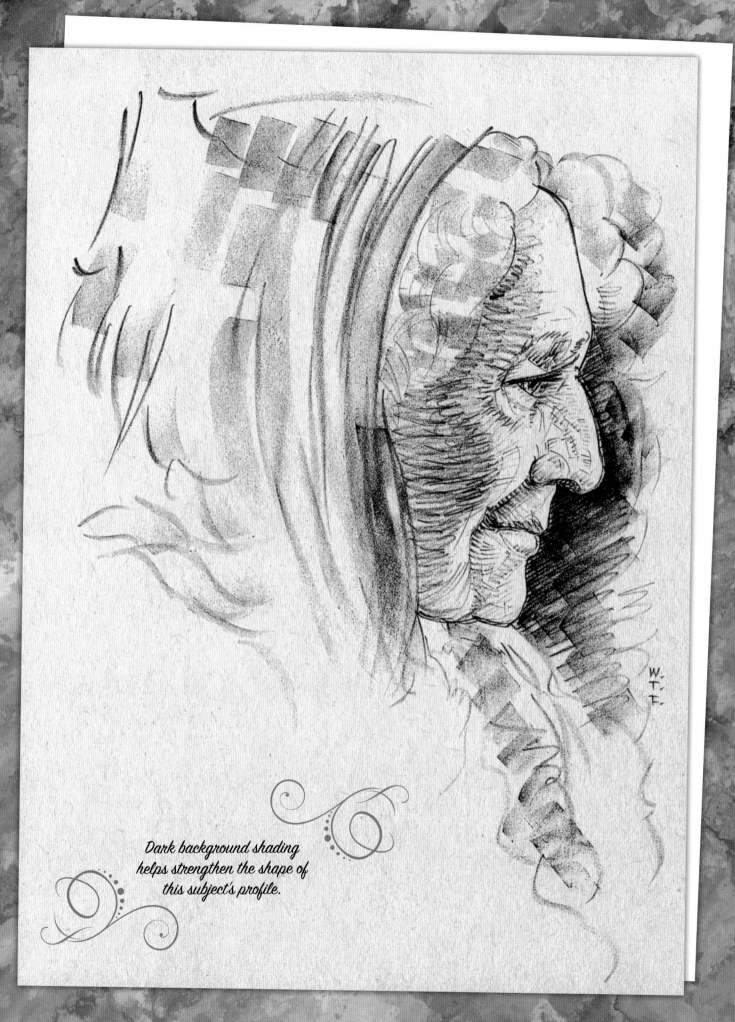

*Dark background shading
helps strengthen the shape of
this subject's profile.*

Men

Elderly men are good subjects for practicing a variety of details, such as wrinkles, thinning white hair, and other features.

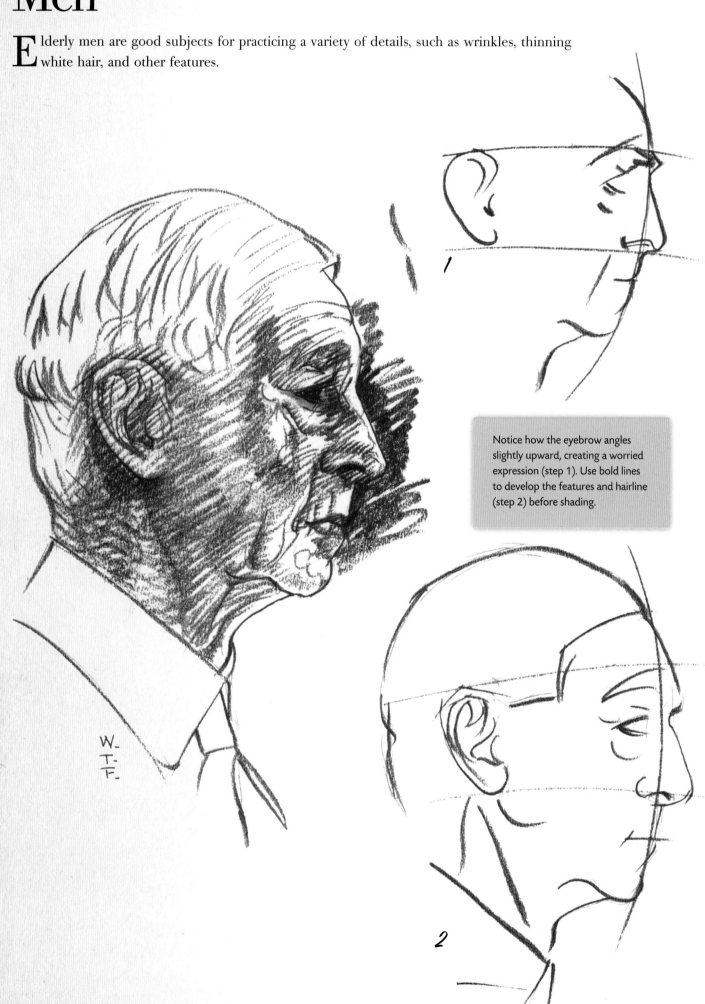

Notice how the eyebrow angles slightly upward, creating a worried expression (step 1). Use bold lines to develop the features and hairline (step 2) before shading.

1

2

W. T. F.

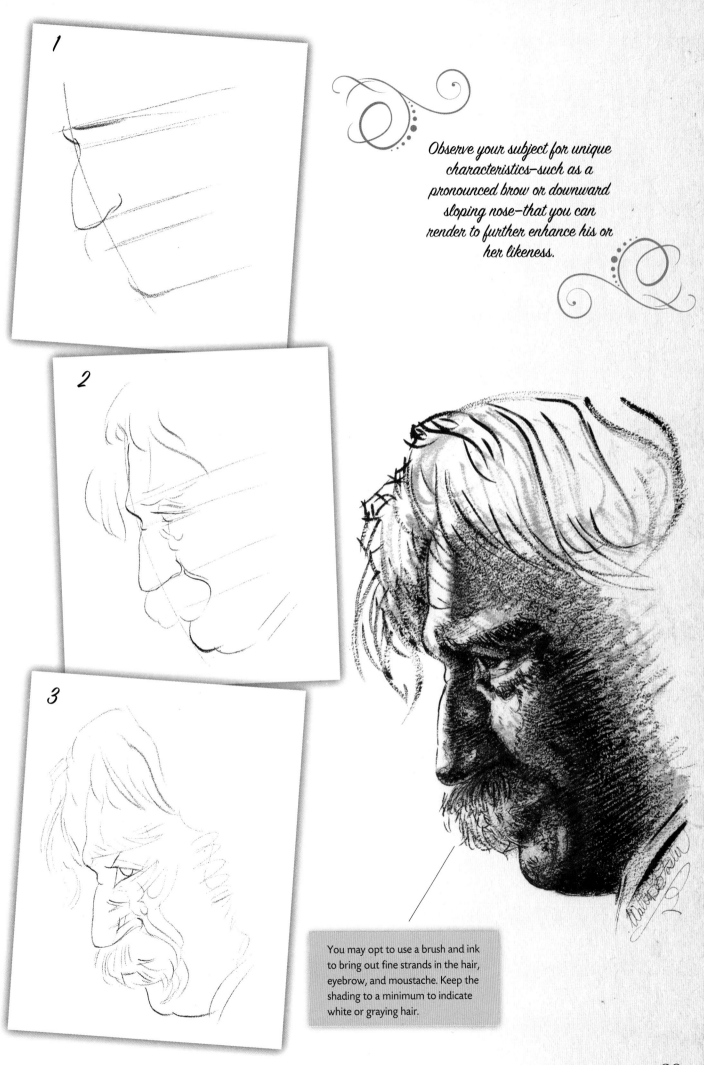

1

2

3

Observe your subject for unique characteristics—such as a pronounced brow or downward sloping nose—that you can render to further enhance his or her likeness.

You may opt to use a brush and ink to bring out fine strands in the hair, eyebrow, and moustache. Keep the shading to a minimum to indicate white or graying hair.

89

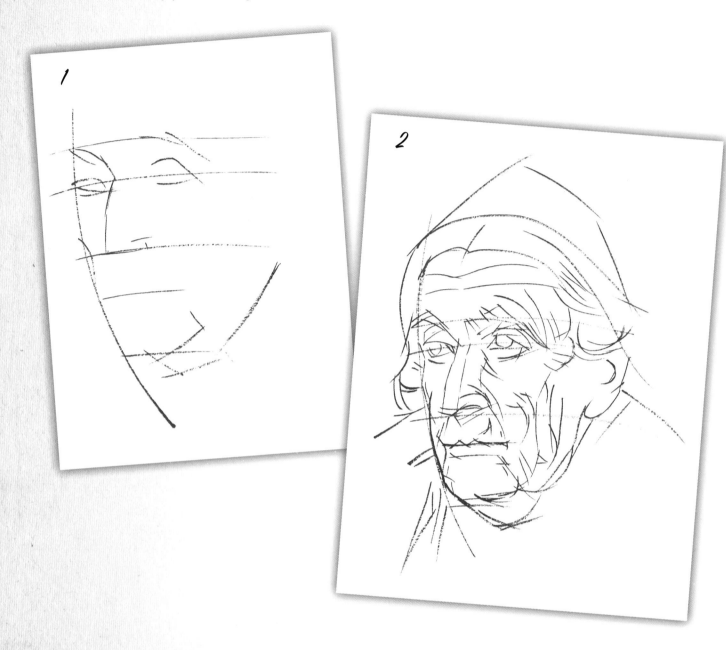

When sketching this subject, pay close attention to the number of strokes it takes to accurately capture the weathered look of the face. Coarse shading over the entire area helps create the rough texture of the skin, but too much can muddy your drawing.

1

2

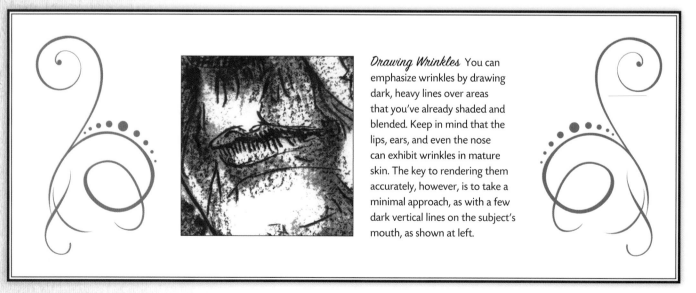

Drawing Wrinkles You can emphasize wrinkles by drawing dark, heavy lines over areas that you've already shaded and blended. Keep in mind that the lips, ears, and even the nose can exhibit wrinkles in mature skin. The key to rendering them accurately, however, is to take a minimal approach, as with a few dark vertical lines on the subject's mouth, as shown at left.

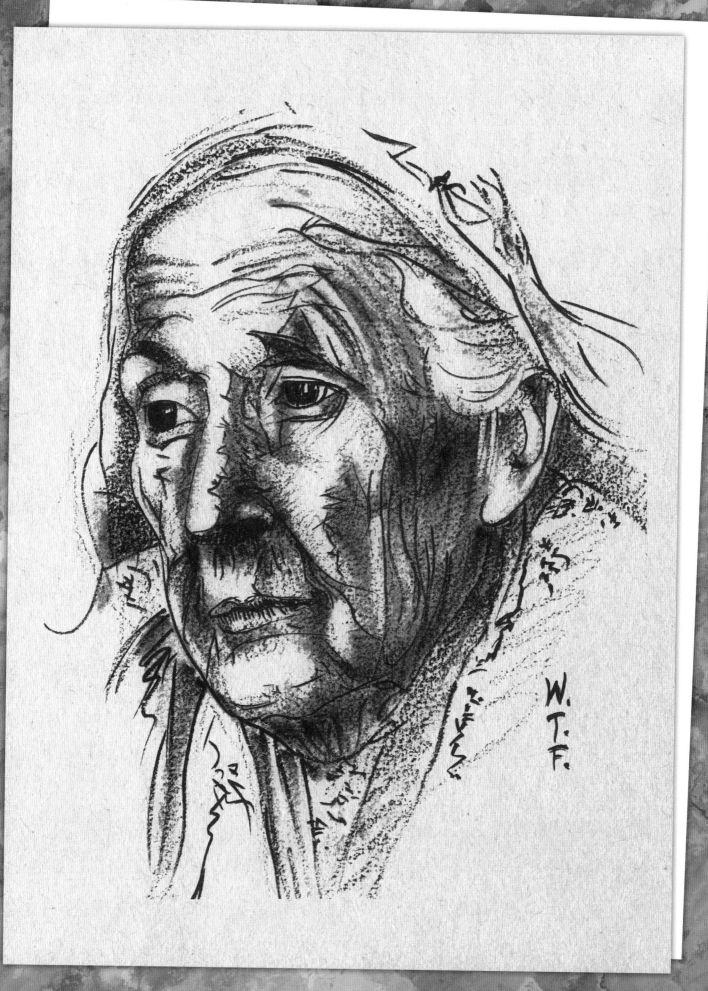

Elderly men with beards are always interesting to draw. But often, merely suggesting the presence of a beard, moustache, eyelashes, and wrinkles creates more interest than attempting to render them from life. Take some time to perfect your technique while working on this drawing, which is more impressionistic in nature.

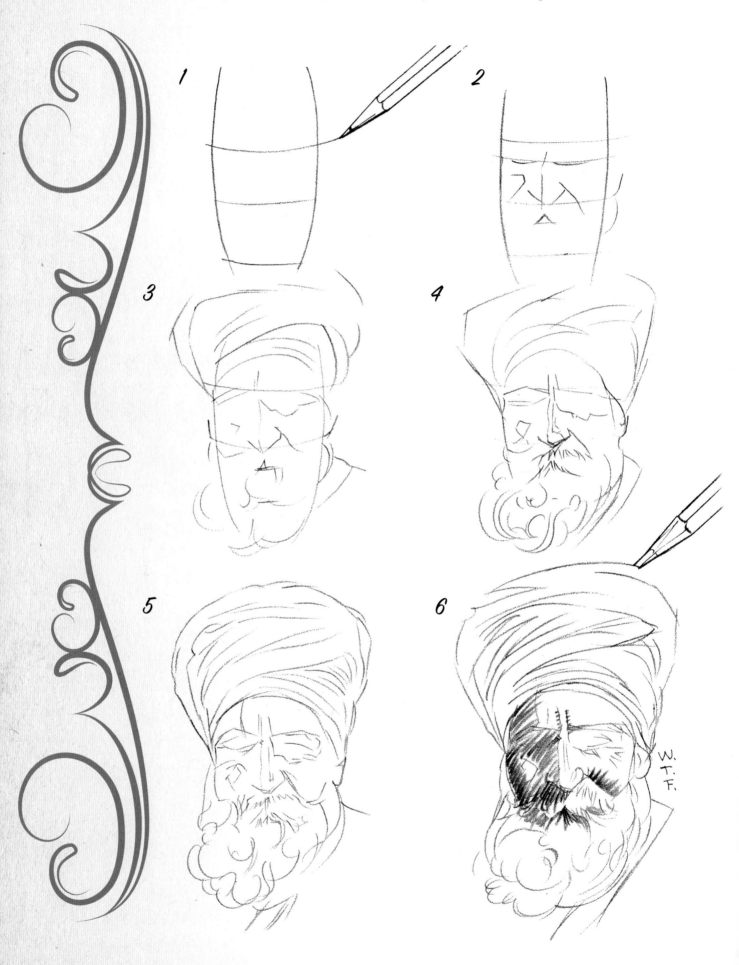

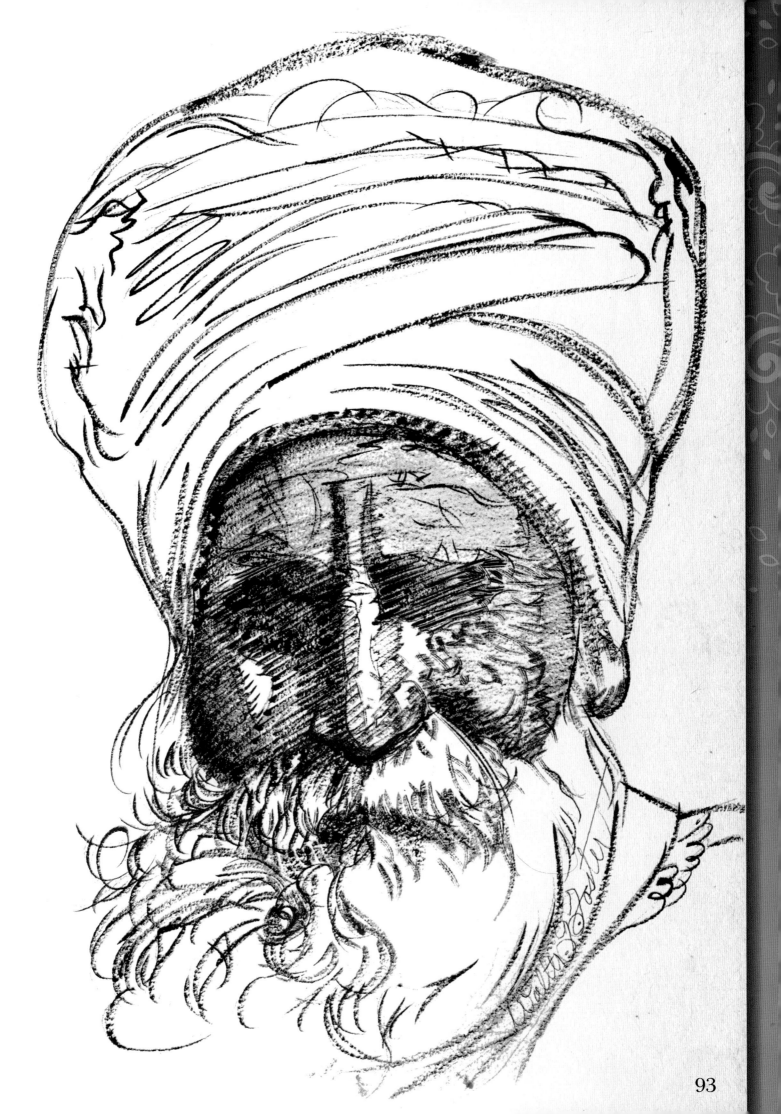

What does this subject's expression tell you? Does it signify anger? Distress? Loneliness? Or is it simply too hard to tell? Sometimes, leaving a drawing open to a viewer's interpretation is a dynamic way to generate interest and an indication that you have achieved a solid grasp of technique.

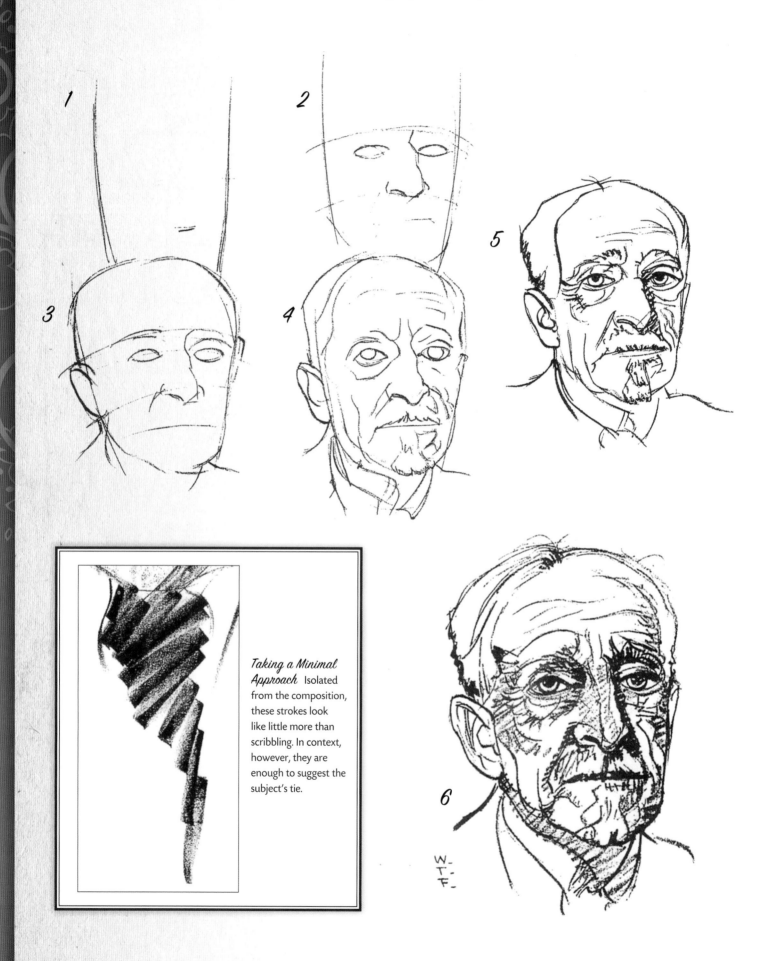

Taking a Minimal Approach Isolated from the composition, these strokes look like little more than scribbling. In context, however, they are enough to suggest the subject's tie.

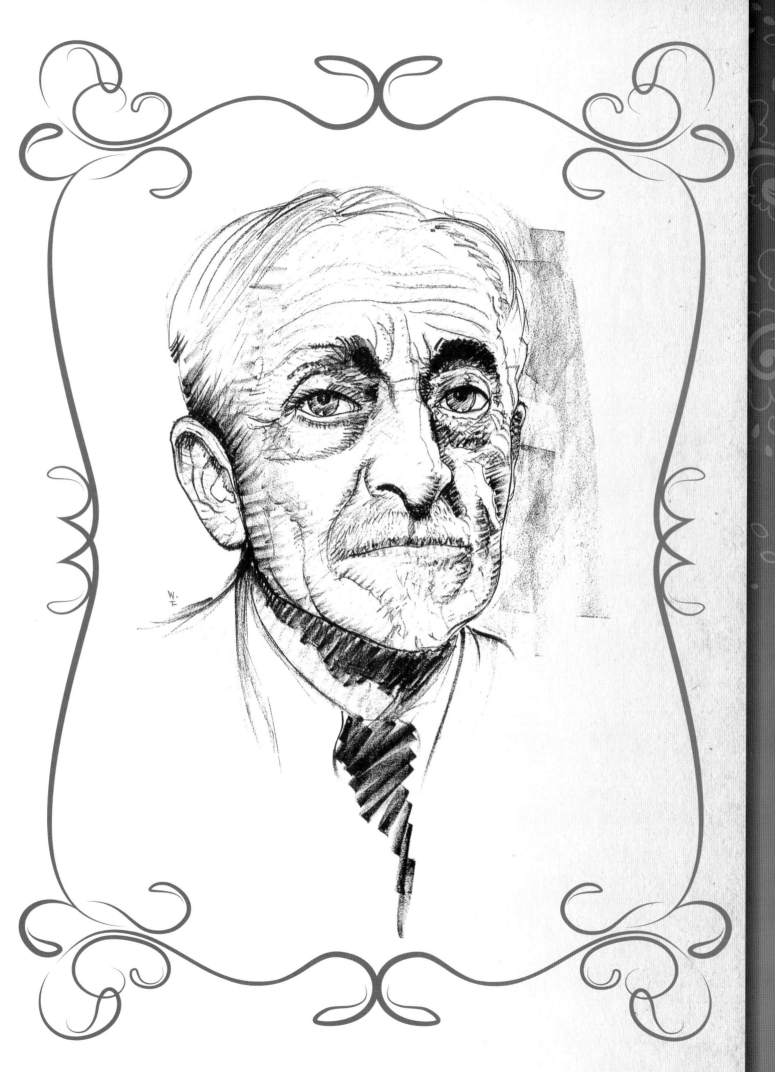

This drawing offers another example of a subject with distinctive facial features. Consider how shading was used to further enhance them. What pencil strokes may have helped add to this drawing's overall authenticity?

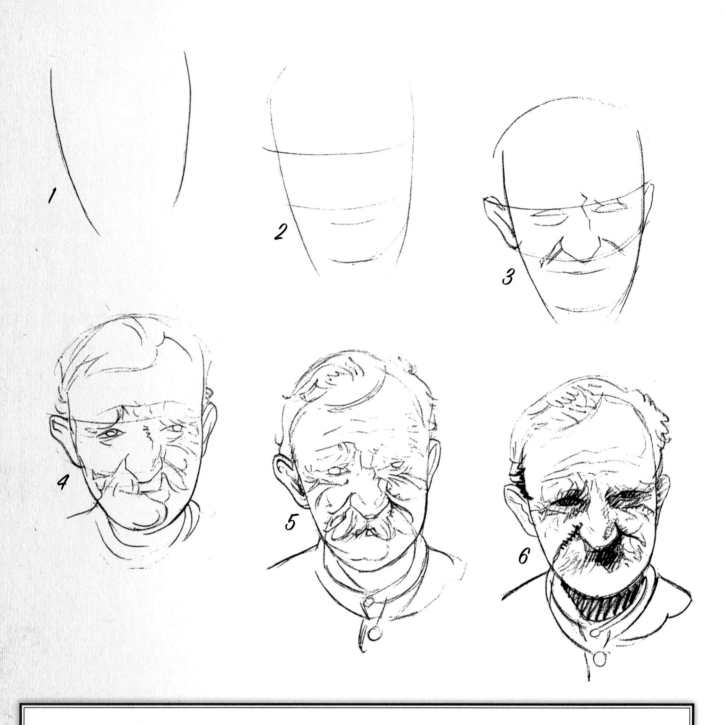

Light Source and Shading Take a look at each side of the subject's moustache. Notice how the left side is lighter at the top and darker on the bottom, whereas the right side is darker and more concentrated at the top, with minimal highlights lifted out toward the middle. Although the subject is facing forward, the highlights on the moustache and face indicate that the light source is coming from the subject's right. Taking note of these details will make a world of difference in your art.

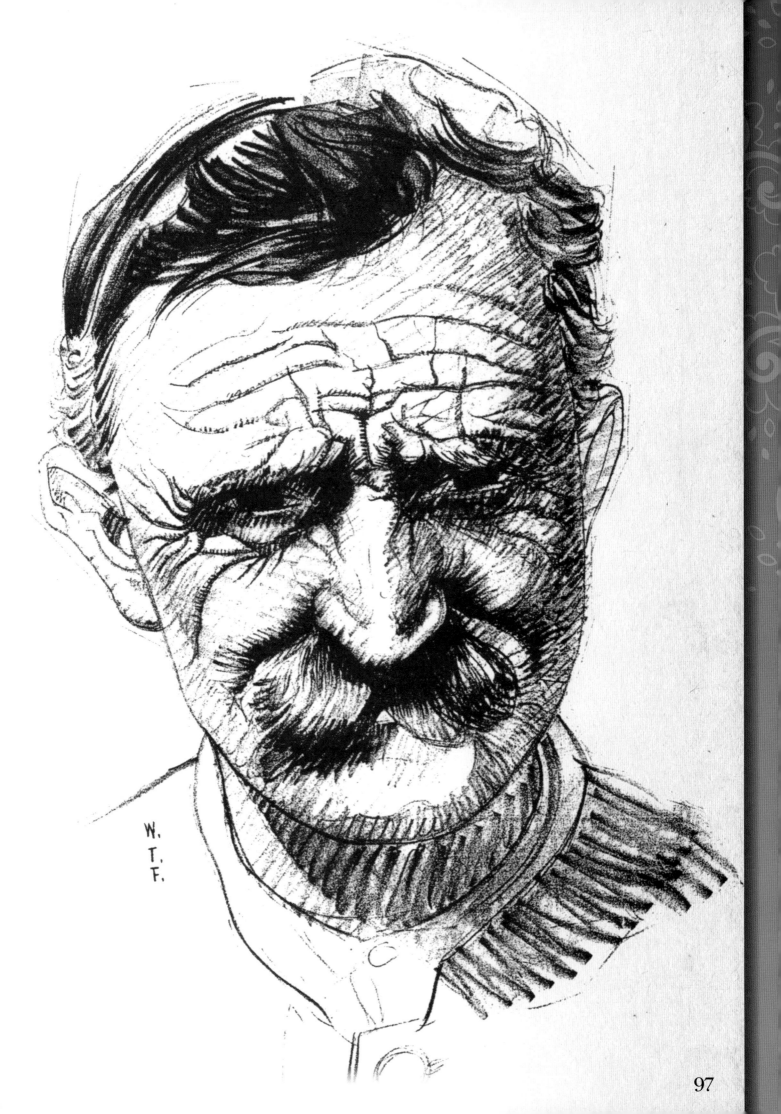

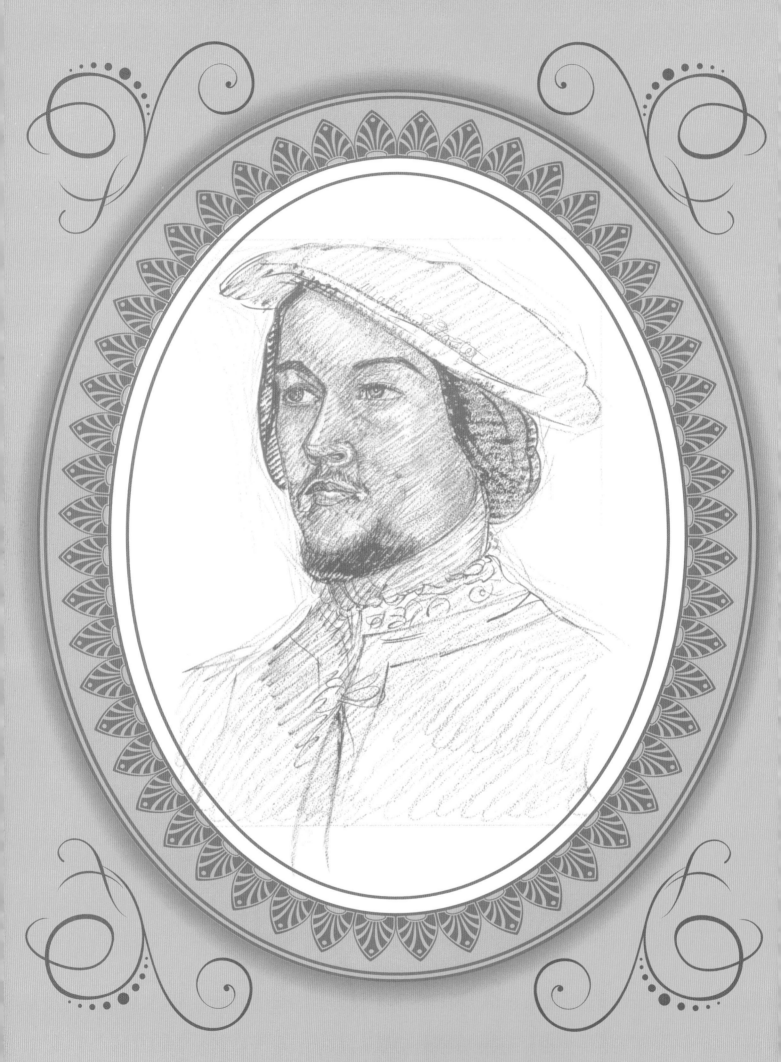

Chapter 5:
Unique Portraits

Now that you have practiced drawing profiles, frontal, and three-quarter views of your subjects in various stages of life, it is time to expand your artistic horizons and steer away from the conventional. It can be beneficial to seek out a drawing subject whose face has irregular proportions or whose features are atypical. Unique facial features will make your drawings more interesting and will challenge you as an artist, as well. This chapter is all about adding that something extra to the ordinary portrait. Whether you use an interesting angle, add flashy accessories, or depict a character from another time period, there are many ways you can add interest and allure to your renderings.

Renaissance Artist

Don't feel as though you have to limit your drawings to modern-day subjects. Experiment sketching favorite subjects from any time period for which you have a particular affinity.

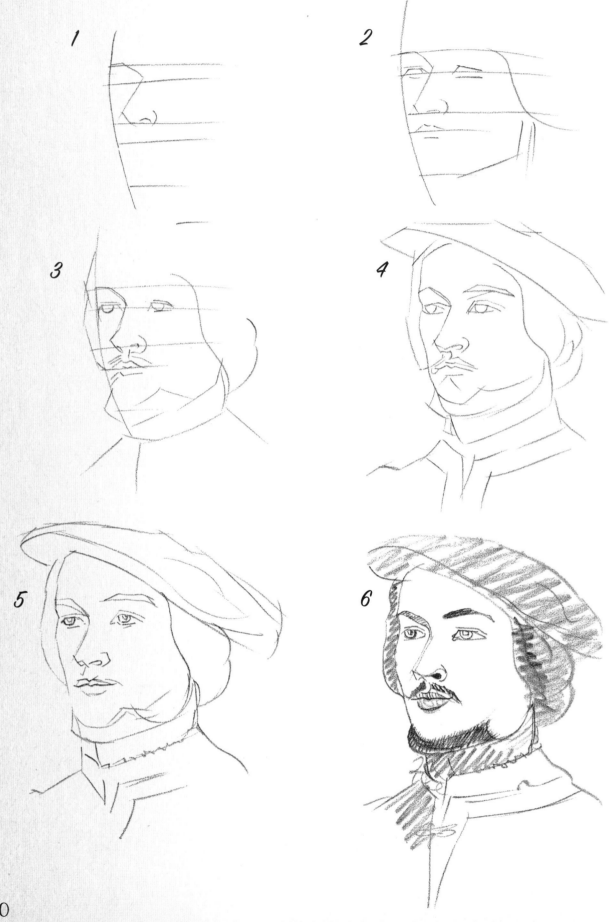

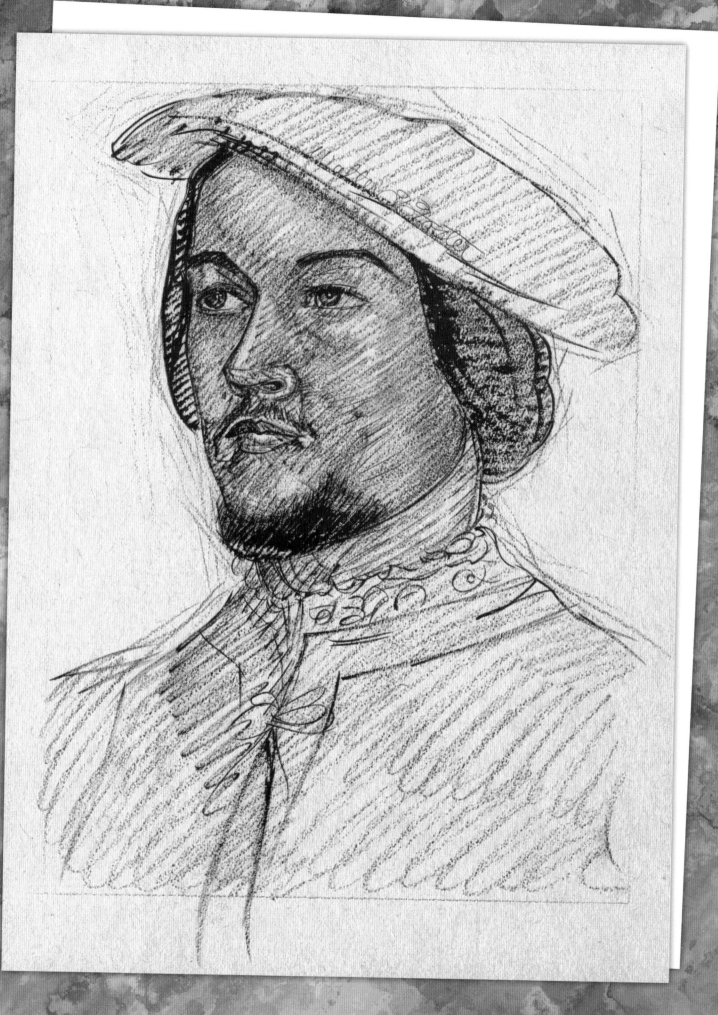

Abraham Lincoln

With his pronounced features and well-defined bone structure, Abraham Lincoln makes a great subject for practicing your drawing techniques.

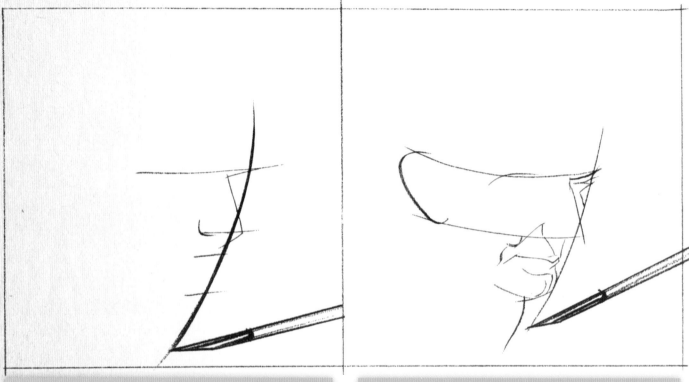

Start by sketching guidelines, marking the locations of the eyebrow, nose, lips, and chin.

Begin to shape the mouth, chin, and nose. Add an outline to mark the ear.

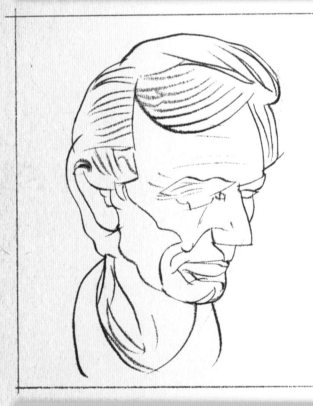

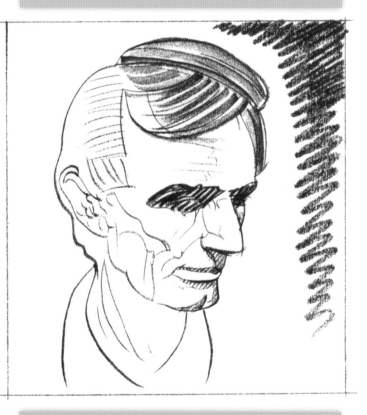

Sketch in the remaining features, including the hair and neck.

Add shading to help refine the lines and add dimension. Continue to sketch, shade, and lift out highlights until you have a true likeness of Honest Abe.

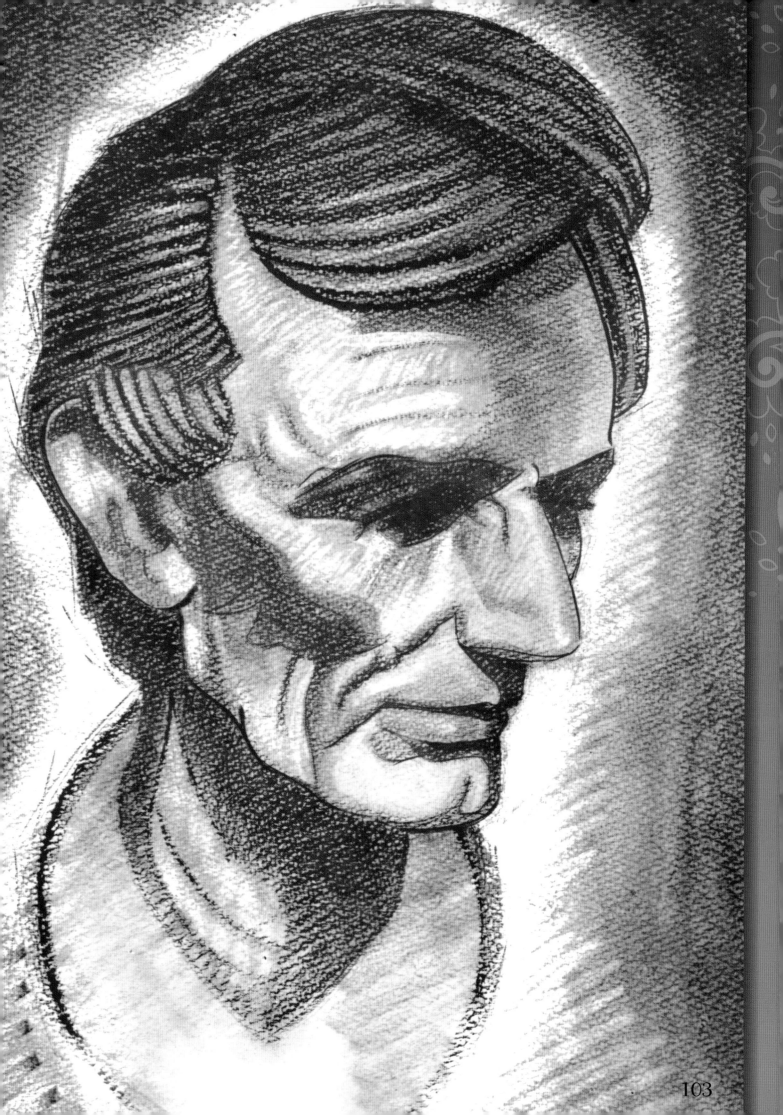

Follow the same basic steps that you've learned throughout the book to draw Abraham Lincoln's profile. Keep in mind that even in a profile position, the facial features are still quite prominent.

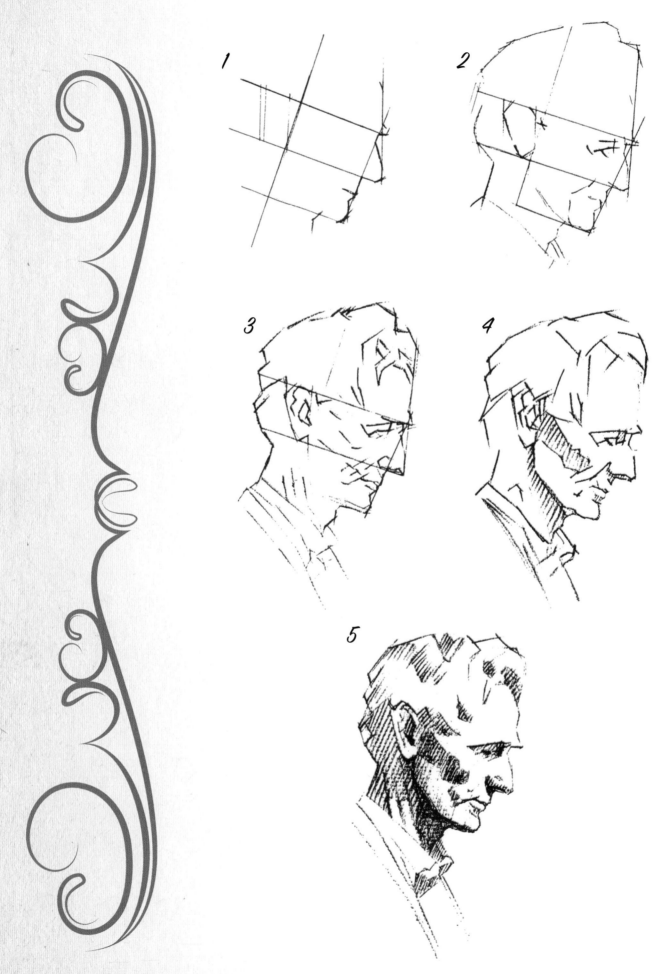

1

2

3

4

5

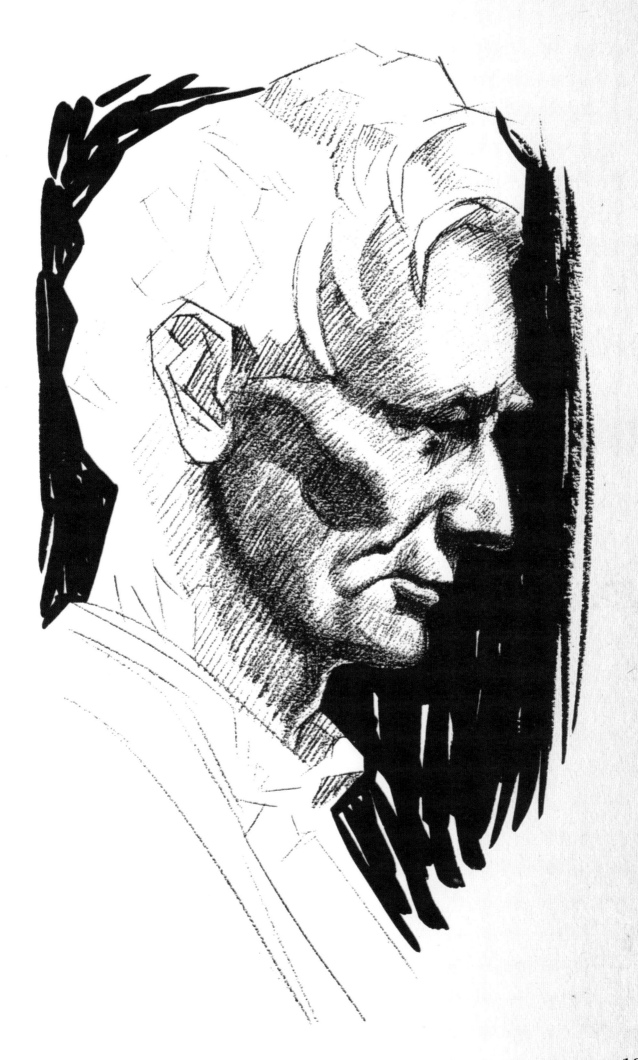

Native American Women

Dark, heavy lines and a liberal use of shading add to the air of wisdom in this subject's face. Review the pencil techniques on pages 9–11. Which do you think were employed to create this drawing?

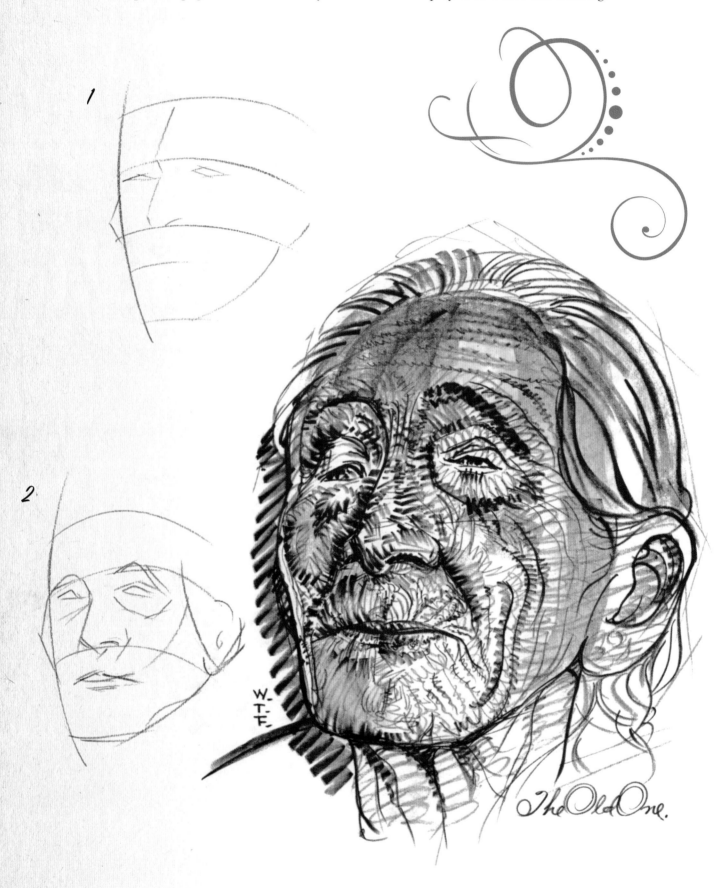

1

2

W.T.F.

The Old One.

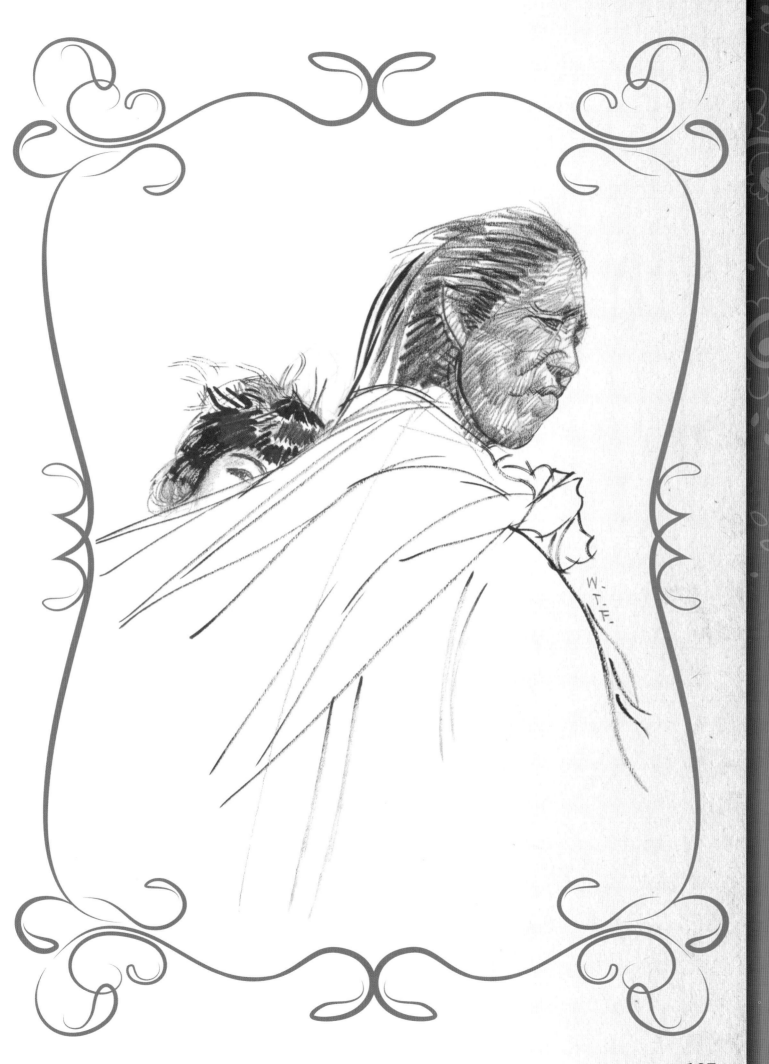

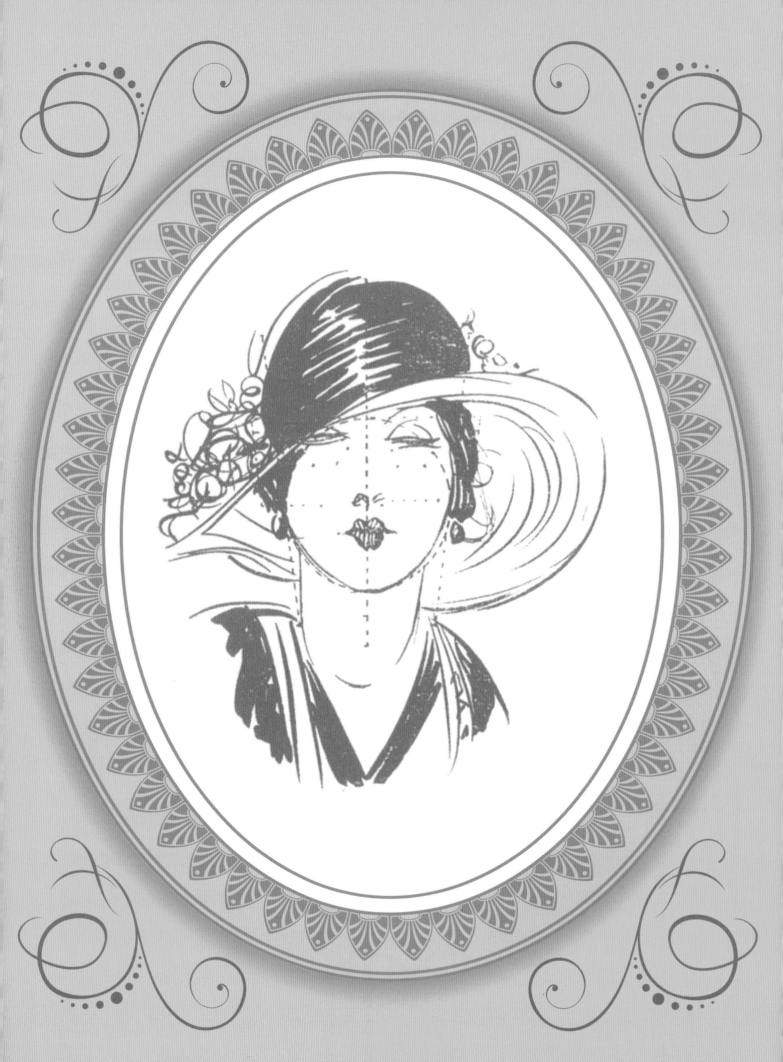

Chapter 6: Sketch Templates & Vintage Art Gallery

This chapter is filled with additional step-by-step faces and finished drawings from the Walter Foster archives. These sketches date back to the early 20th century, illustrating the myriad fashion trends of that period and earlier. You'll step back in time as you peruse these pages filled with a diverse selection of images. From women with dangerously short hair and daring fashions to men in classic fedoras to little girls with ribbons and curls, these are the faces of yesteryear.

As you perfect your drawing techniques, perhaps you, like Mr. Walter Foster, will immortalize some of the faces of your time for future generations to gaze upon with curiosity and awe. Enjoy!

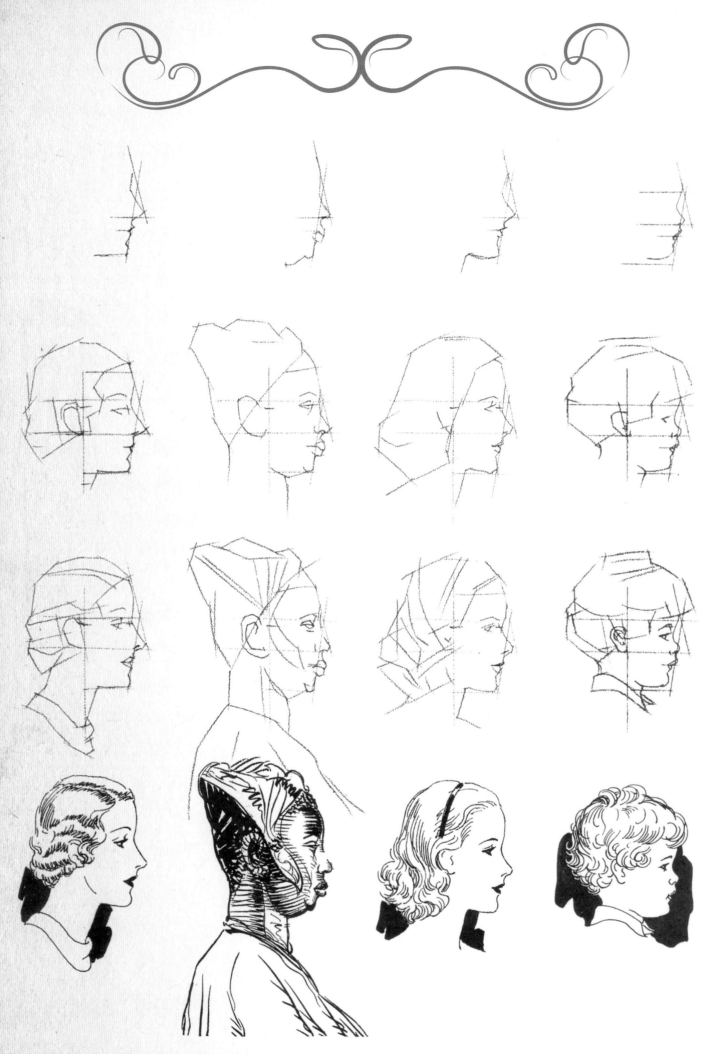

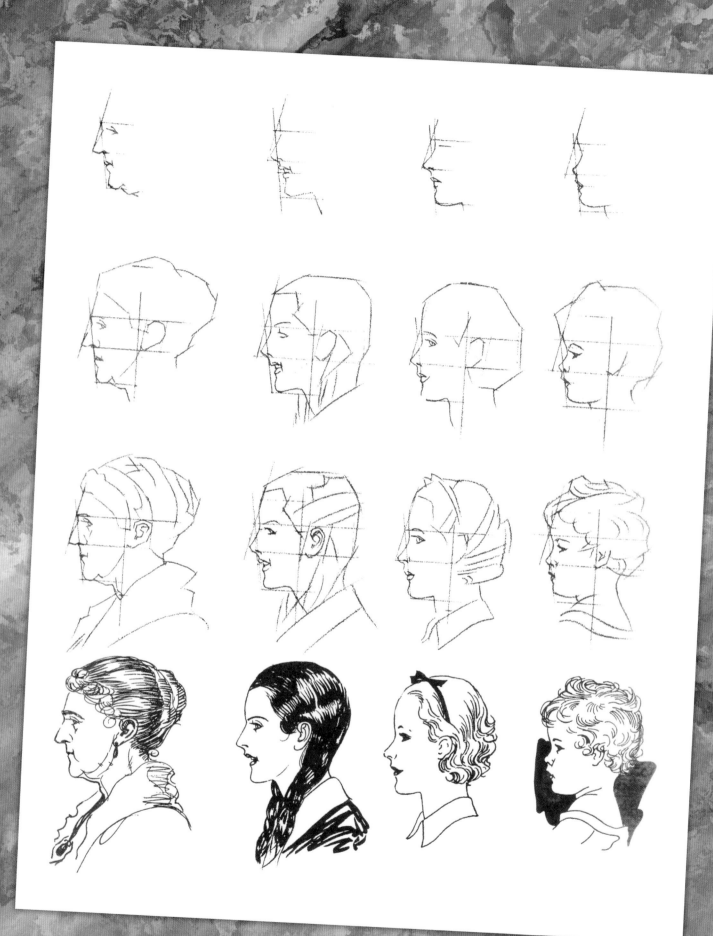

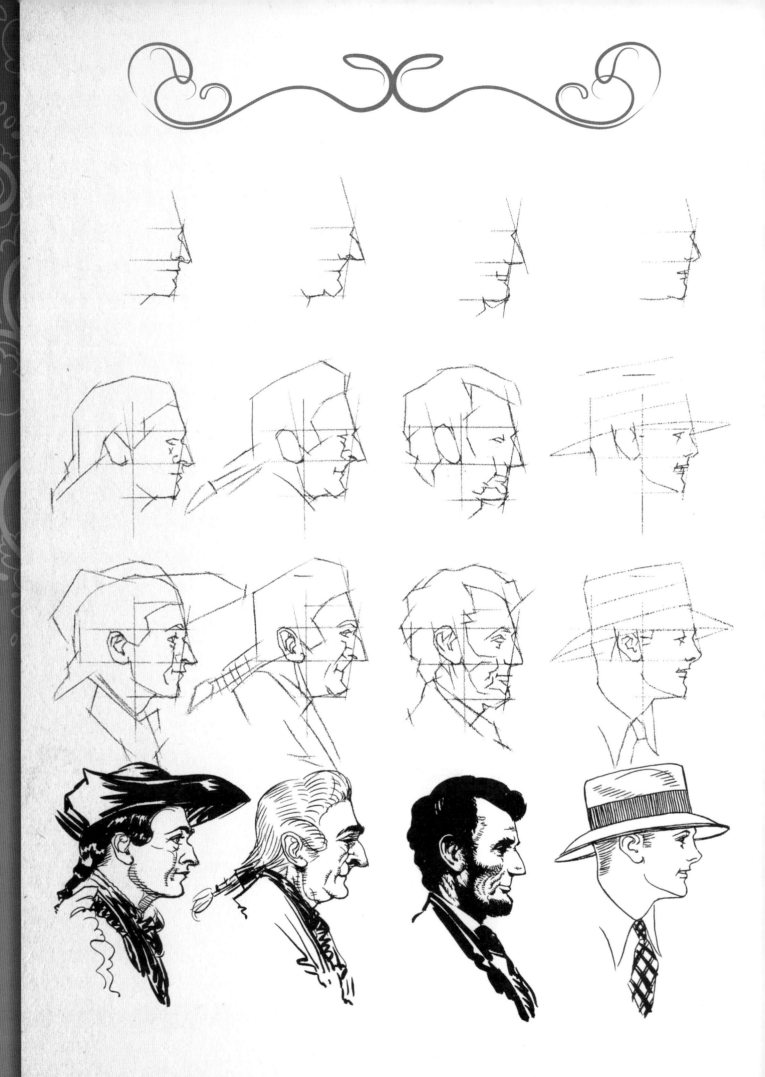

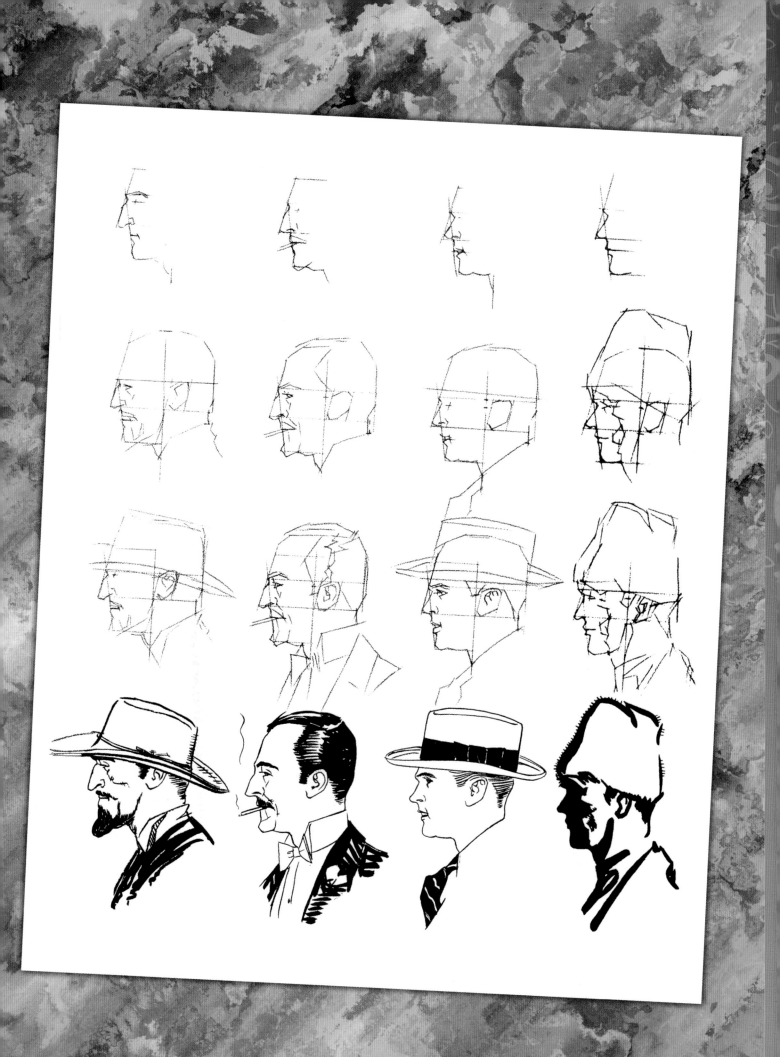

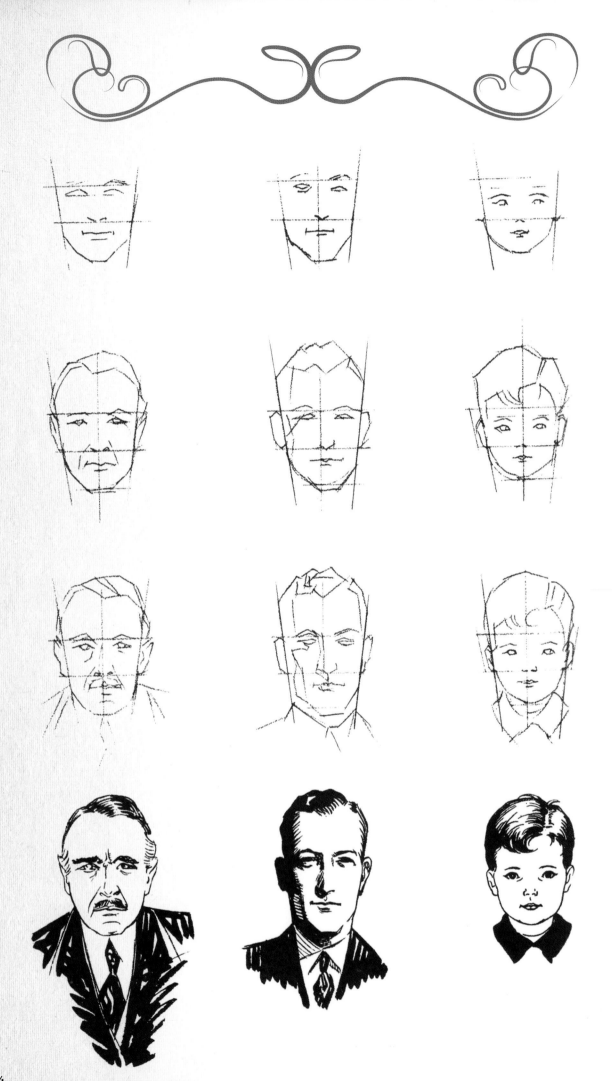

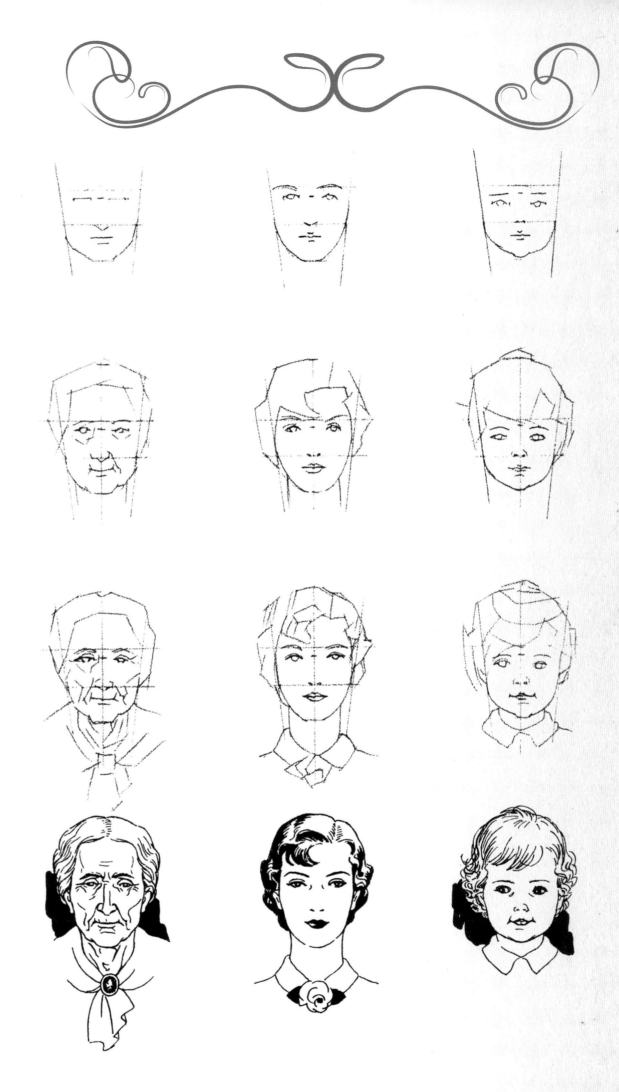

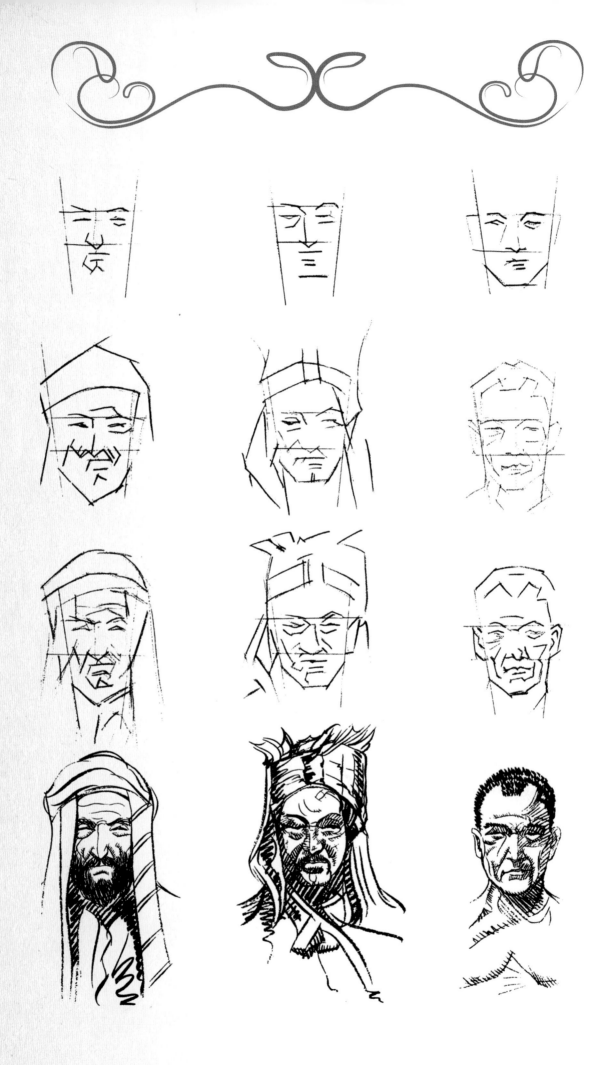

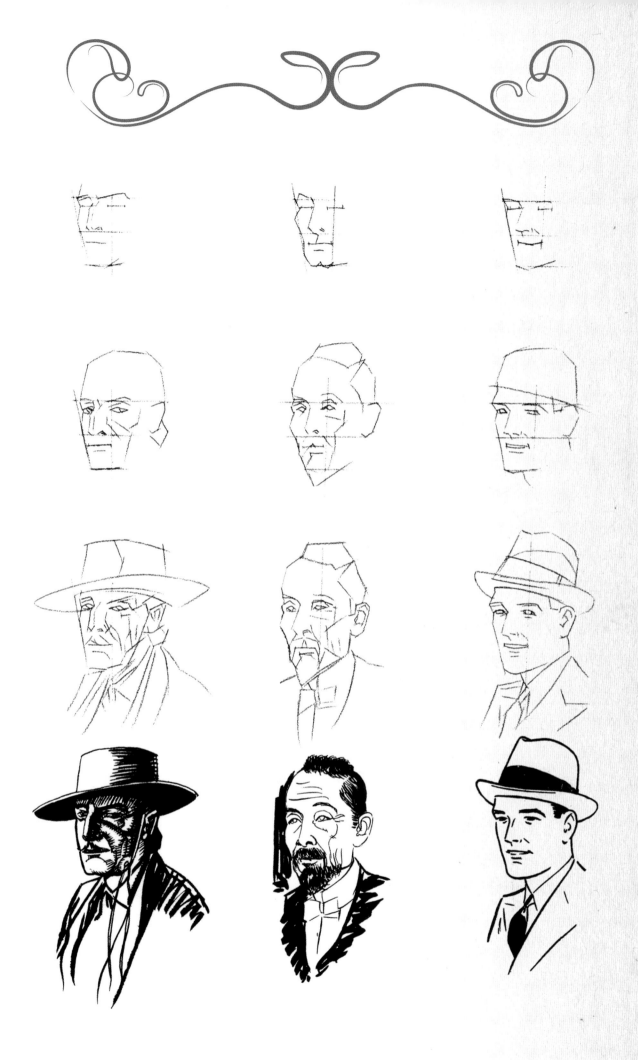

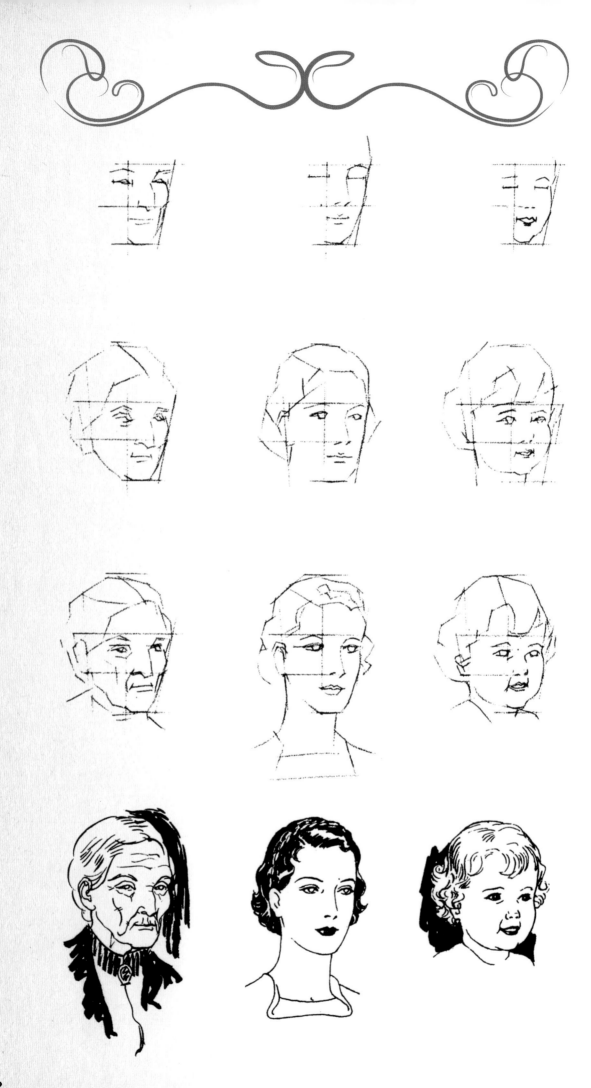

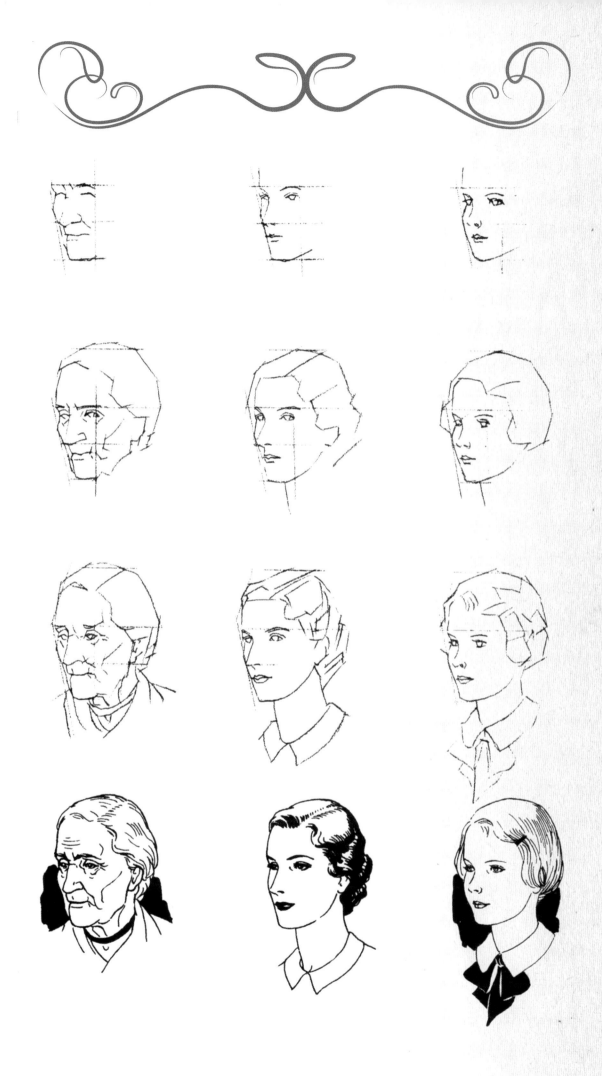

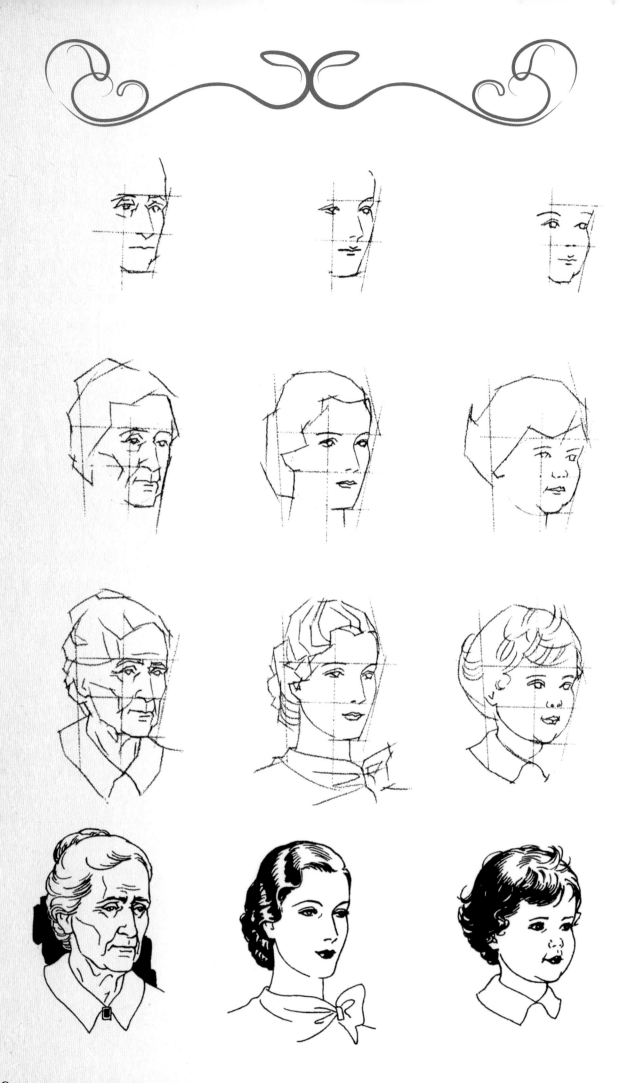

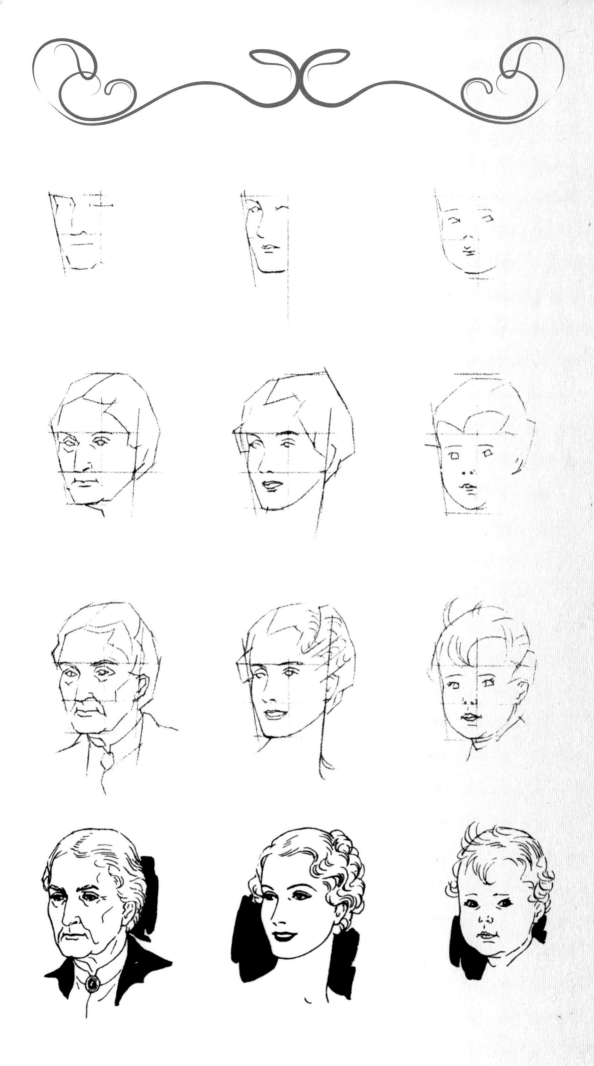

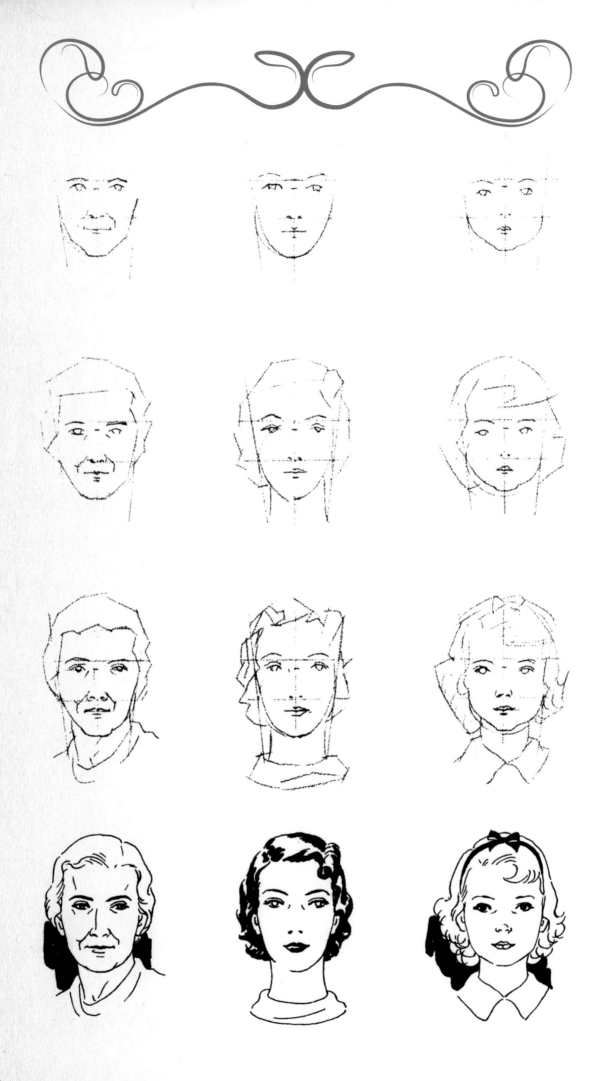

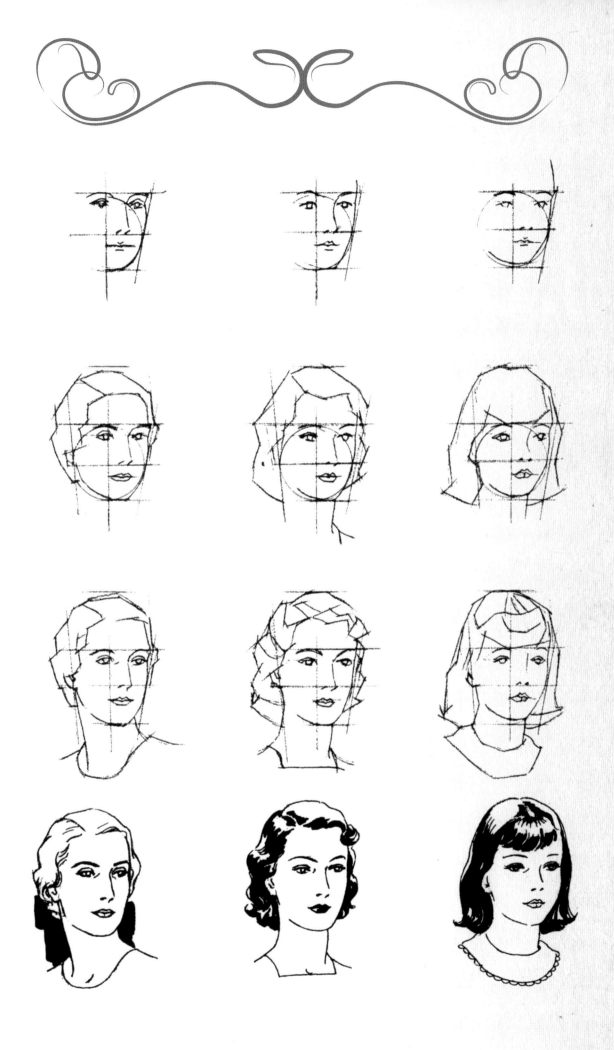

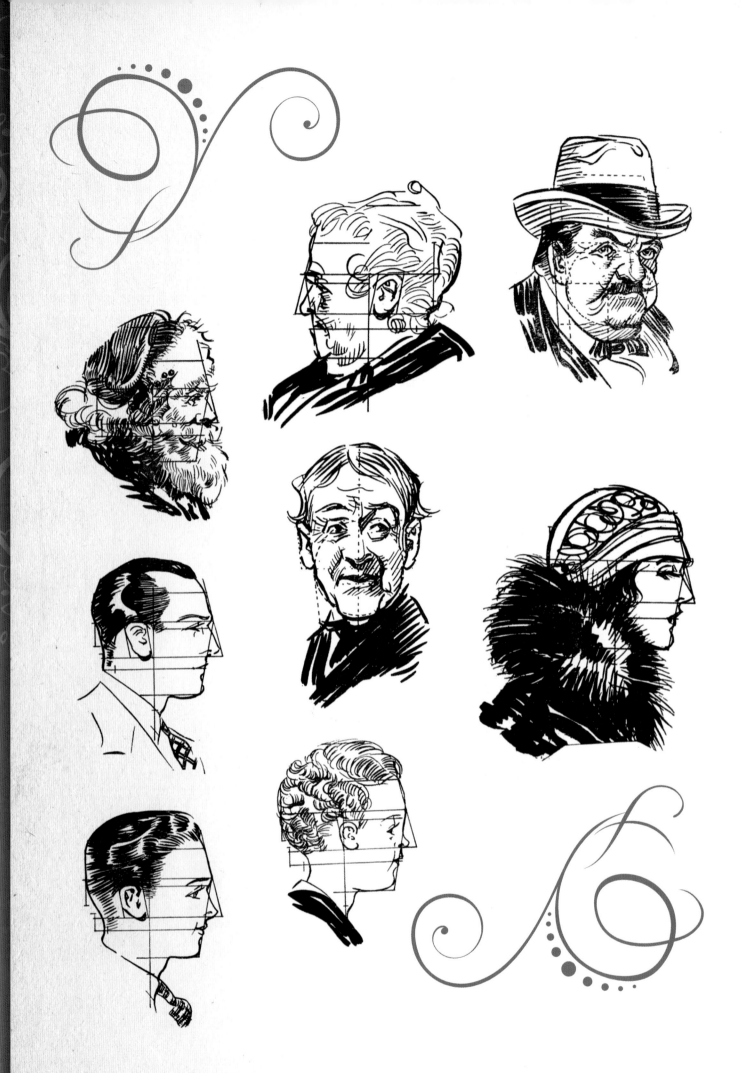

124

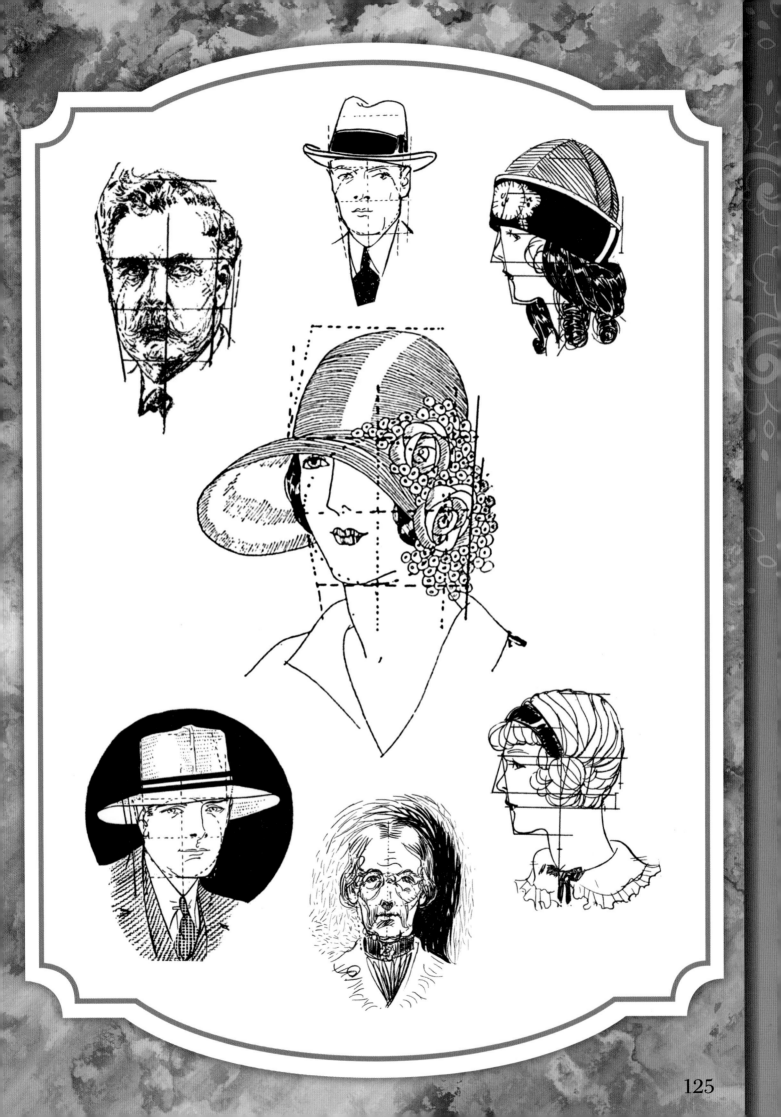

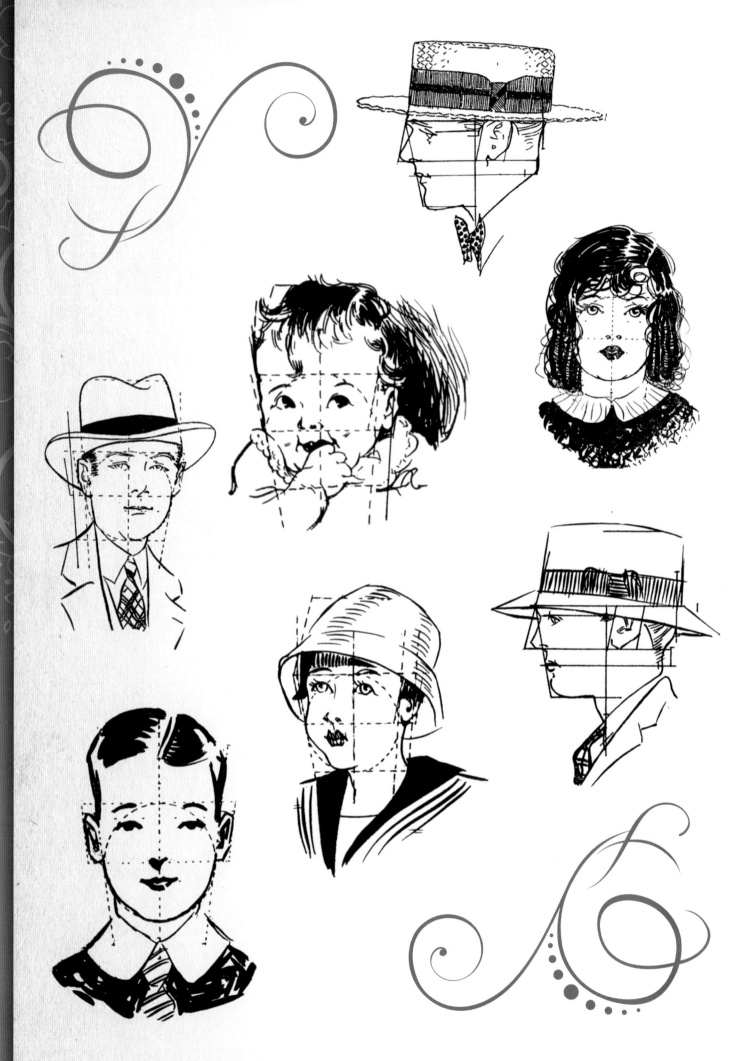

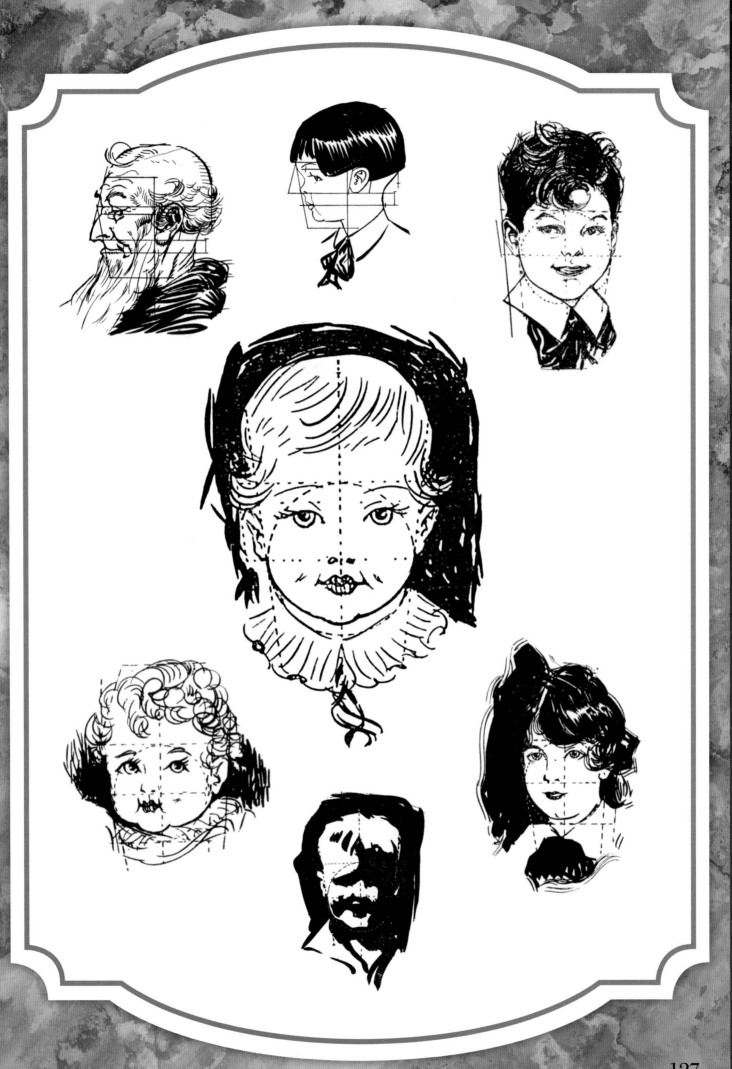

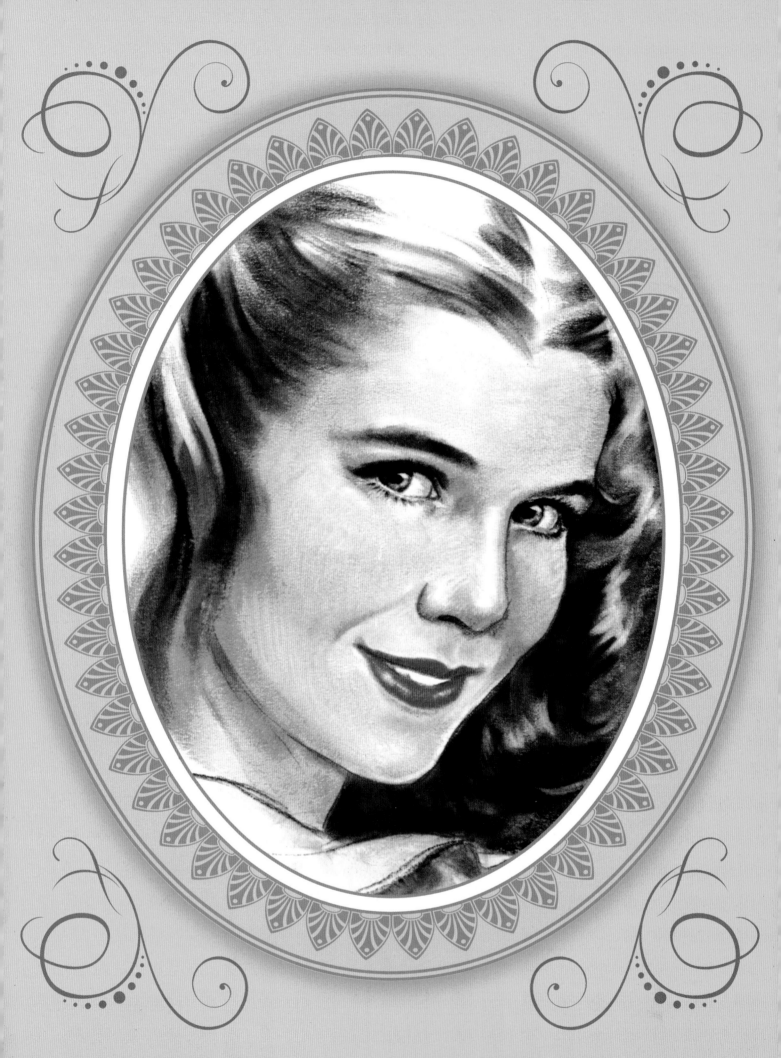